CRITIQUED

nside the Minds of
23 Leaders In Design

CHRISTINA BEARD

 Peachpit Press

CRITIQUED
Inside the Minds of 23 Leaders in Design
Christina Beard

Peachpit Press
www.peachpit.com

To report errors, please send a note to errata@peachpit.com
Peachpit Press is a division of Pearson Education

Project Editor: Nancy Peterson
Production Editor: Tracey Croom
Development Editor: Bob Lindstrom
Copyeditor: Darren Meiss
Proofer: Scout Festa
Compositor: Kim Scott/Bumpy Design
Indexer: Emily Glossbrenner
Cover Design: Chris Clark
Interior Design: Christina Beard

ISBN 13: 978-0-321-89741-1

ISBN 10: 0-321-89741-2

9 8 7 6 5 4 3 2 1

Printed and bound in the United States of America

To my nephew Kai,
who has helped me see the world
in so many new ways

ACKNOWLEDGMENTS

I am truly grateful for Ellen Lupton's tremendous support and encouragement throughout my thesis and in writing this book. I'm thankful to be part of the MICA community. Students, alumni, and faculty continue to be a constant source of feedback and inspiration.

David Barringer forever changed the way I think about writing. He helped me gain the confidence needed to write this book and graciously contributed his own writing.

All of the participating designers who gave their time and welcomed me into their studios and even their homes truly made this book possible. It was a humbling experience that made me feel optimistic and even more excited about the design community.

I'm indebted to Nikki McDonald at Peachpit, who championed this book, to my editor, Bob Lindstrom, and to everyone at Peachpit who helped get it produced and published.

Finally, my friends and family were the keel that kept me balanced. Early on, Ryan Foley helped me frame this project. Chris Clark gave me honest feedback and a beautiful cover. Andrew Shea helped keep me grounded, offering design feedback, editorial insight, and a friend I could always call on. Renata Hocking, Nathan Manire, and Ayo Yusuf offered feedback, friendship, and encouragement.

My family has always supported me, encouraging me to be fearless in any project I undertake. My sister helped me remember that a skillful sailor can sail in any direction. Patience allows a sailor to tack from side to side, coming a little closer to the destination with each turn.

CONTENTS

THE ANALYSIS

FOREWORD

Ellen Lupton

What goes on inside a designer's head? Alas, we will never know. What we see of that mental process is what's left behind in sketches, drafts, prototypes, and the occasional post-facto press release. Digital tools allow designers to create endless iterations of an idea, and yet these ephemeral phases of life are often erased at the journey's end. Our digital clouds would crash to Earth under the weight of every designer's iterative load.

Christina Beard set out to record the process of creating a single poster, and she sought to make her endeavor a collaborative one, seeking out advice from leading designers in the field. Much of what happens in the making of a poster, publication, or brand campaign doesn't take place on screen or page at all; it unfolds in conversations between designers, clients, users, and other stakeholders.

This remarkable book tells the story of Beard's encounters with designers around the world who agreed to look at her work and advise her on where to go next. Beard gave herself a simple rule to follow: No matter what her mentors told her to do, she would try her best to do it, even if it sent her on a sudden U-turn or down a dark forest path.

At the core of her experiment was a generic brief: Create a poster encouraging people to wash their hands in the restroom. This universal message intends only to reinforce a simple behavior and awareness in its viewers. And yet the approaches to achieving this end are myriad. Should the poster rely on facts, emotions, or feelings of disgust? Should it praise the viewer or judge them, inform them with data or shake them up with images of pestilence and filth? Should the poster emphasize the social impact of disease control or should it speak to the viewer's private longing for personal well-being? Should the imagery be literal or abstract, scientific or suggestive?

Beard's project, which began as her MFA thesis at MICA (Maryland Institute College of Art), has yielded a compelling story about the design process. As we watch this poster repeatedly reinvent itself, we are invited to join her conversations with a diverse range of designers and critics who speak to us about the state of the field and share their thoughts about design research and experimentation. Designers, educators, and students will have much to learn from Beard's brave quest, as they witness an initial idea twist, turn, and transform in response to fresh waves of input from some of design's most fascinating personalities.

INTRODUCTION

Design is limitless.

There are many ways to approach your work, to think about your audience, and to express a message. And there's never one perfect design solution. This book takes you on a journey, meeting with 23 design leaders to see how they would approach a simple task: Create a poster to encourage people to wash their hands.

Throughout this journey I met with leading designers with my poster in tow. At each stop the designer critiqued the current version of the poster and talked about his or her design approach. I then redesigned the poster, based on our meeting, and traveled to the next designer with the new poster.

Meeting with each designer gave an inside look at how they approach their work, what process they use, and where they see the future of design. Each conversation revealed how a designer's background, experience, and personality shapes their work.

This journey started as a graduate thesis at Maryland Institute College of Art. I wanted to design a year-long project that allowed me to gain a broad perspective of the current state of design, rather than concentrate on one school of thought. Each conversation allowed me to learn and inhabit the mindset of an established designer, and the quick iterations enabled me to explore their approach.

I wanted to know how designers think about their designs. I wondered, "What do they think about first?" "What do they think about last?" "What helps shape their work?"

Learning about their process and approach was important, but it was also essential to observe how they physically responded to the work, how they talked about design, and how their personalities shaped the way they think. I made a set of rules to guide me. It was important for me to meet in person with every designer, a decision that took me to Europe and throughout the United States. The poster had to stay a poster and keep its dimensions of 18" x 24". And finally, it was essential that I strictly follow the advice of each participant, even if it was difficult or uncomfortable.

This book guides you through 23 unique ways of thinking, with short design briefs to inspire you and reshape or redefine your own thinking. It's not meant to be read front to back. Jump around and get to know the designers you're drawn to first, and then return to the ones you're not so familiar with. This book offers an action-oriented guide to mix up your design routine with fresh perspectives. I invite you to explore and experiment by inhabiting the mindset of 23 leaders in design.

THE EXPERIMENT

The following chapters chronicle an iterative design experiment, fueled by a sequence of critical conversations with 23 leaders in design. In this experiment, I produced 25 posters that represent the diversity of current design approaches and personalities in the field.

ELLEN
LUPTON

LOCATION Maryland Institute College of Art, Baltimore, MD

EDUCATION BFA, Cooper Union; PhD Communication Design, University of Baltimore

EMPLOYMENT Curator of Contemporary Design at Cooper-Hewitt National Design Museum, Director of the Graphic Design MFA program at Maryland Institute College of Art

DURATION OF REDESIGN 11 days

"I'm interested in the written message. It should feel like an integral part of the poster."

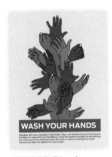

BEFORE Ellen's feedback

Ellen, responding to the poster

"If I were to design this poster it would be purely typographic," Ellen said. "I'm interested in the written message. It should feel like an integral part of the poster," she said. Language lies at the center of Ellen's work. She's well known for her mastery of merging language and image to create powerful works—whether it's editorial illustrations or a curated exhibition.

Ellen has dedicated the bulk of her career to making design literacy part of the mainstream. She's created a collection of books that aim to educate the public about graphic design and how it impacts their lives. On the other end of the spectrum, she curates the best design from around the world for the Cooper-Hewitt National Design Museum. Ellen does it all.

We met in her office at MICA, where she scanned over the poster. Her small dog Jack was perched on my lap. She advised me to explore ways to integrate the image and message by literally merging the two.

"What if the hands were holding the message?" she asked. For Ellen, the totem of hands referenced a social element.

"It suggests that it isn't just an individual choice, but that your actions affect everyone," she said. The hands reminded her of gestures, sign language, and communication. She suggested that the facts be integrated into the hand gestures.

"Right now it feels like a perfunctory blurb, " she said. Ellen was blunt and concise in her feedback. She dissected the language—its placement, its tone, and its interaction with the image.

"I don't get a sense of urgency from the poster," she said.

"Where is the poster going to appear?" she asked, "Is it on the door as you leave, when it's kind of too late? Or is it in the stall, or over a urinal?" She felt that the location of the poster could help inform the language.

"How would people implement this into their lives?" she asked. She felt that the idea of hand washing is universal, and yet there are many different ways to convey it—so many different tones. So why not let people choose their own poster?

"Depending on whether it was an office or a school, for kids or health care providers, or at home for your family, it would be a totally different kind of approach," she said. She imagined a set of 20 posters and people could choose which one they wanted. Ellen liked the idea of breaking the traditional notion of one designer creating one design for everyone. She preferred the idea of giving everyone a choice.

Illustration by Ellen Lupton

Ellen was brief and somewhat ambiguous in her feedback. She encouraged an approach that integrated image and text, engaged the viewer, and created a sense of urgency. She specifically mentioned trying to move the text up and merging it with the image.

Book by Ellen Lupton

Back in my studio, I started sketching her specific suggestions, beginning with a large typographic poster with statistics to educate the viewer on why hand washing is effective. Next, I created hands holding the statistics. Then I moved on to hands forming sign language. Since Ellen liked the social element of many hands in the poster, I wanted to play that up and continue using the image of the hand. While I sketched I focused on equally balancing image and language.

"...why not let people choose their own poster?"

After sketching, I created digital mock ups that allowed me to quickly visualize all of my ideas and see how the text and image worked together. Ellen's feedback pointed toward endless creative directions. After a day of sketching and creating mockups, I chose one direction to refine.

In the end, the language presented illnesses you could get as a result of not washing; and the hands and language were literally entwined.

PROCESS Exploring language and image integration

This redesign forced me to think about language and image as equal partners.

While language is essential to Ellen's process, I found it challenging to visualize language in a way that created a sense of urgency but didn't forcefully command the viewer to action.

ELLEN LUPTON ON DESIGN AND LANGUAGE

Book by Ellen Lupton and J. Abbott Miller

Do you have a unique process or a particular way you approach design?
I like to have a sense of humor. I like to think about my audience and how they will confront something. How it will speak to them, in particular.

Were you taught a particular process or is this something you developed over time?
There wasn't a particular process, except an emphasis on thinking about language and thinking about graphic design as a language proposition, as opposed to a purely visual one; and that's something that has always been part of my identity, training, and orientation as a designer.

Book Cover design by Ellen Lupton

If you're stuck on a solution, what do you do?
I do something else—clean my house, check my email, go cook dinner. There's always something to do. Stepping away and coming back a few hours later, or a few days later, helps. Beating an idea to death doesn't help. I think it really benefits you to develop a project over time. I spend repeated time coming back to most things I work on that are successful. Thinking about a project when you're not working on it really enriches the work.

How often do you experiment?
I don't have much time to experiment. I'm usually working on the thing itself but that doesn't mean I always get straight to the solution. It's the iterative thing, trying different things, but I always think I'm actually designing the final solution.

"Beating an idea to death doesn't help."

Where do you see the future of design?
Design is increasingly a tool for people to use, as opposed to an end product. So I would be interested in how people are going to implement it in their lives. An element of choice and an element of personalization is part of the future of design, as opposed to a kind of single message that's handed down on high for everybody to follow.

"An element of choice and an element of personalization is part of the future of design..."

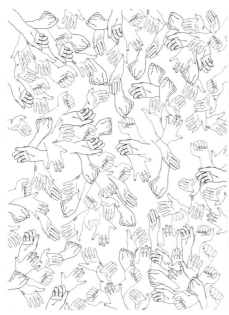

PROCESS Exploring a hand pattern

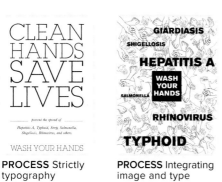

PROCESS Strictly typography

PROCESS Integrating image and type

PROCESS Integrating image and type

PARTNER LANGUAGE AND IMAGE

Explore how language and image work together. Focus on integrating the two. Think about language as an equal partner to image and how one would implement this into their lives.

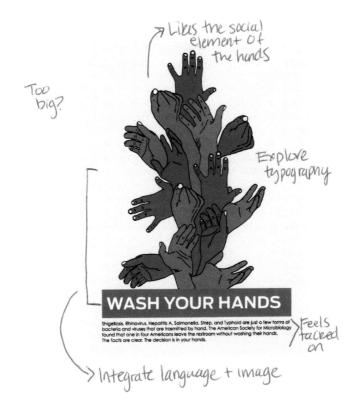

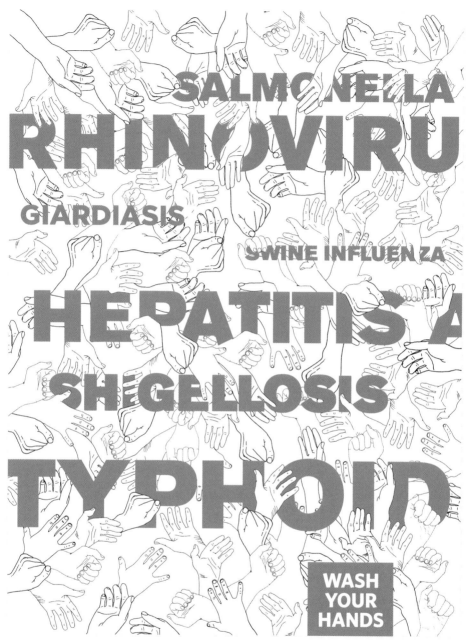

SALMONELLA

RHINOVIRU

GIARDIASIS

SWINE INFLUENZA

HEPATITIS A

SHIGELLOSIS

TYPHOID

WASH
YOUR
HANDS

AFTER Ellen's feedback

PAUL
SAHRE

LOCATION	Office of Paul Sahre (O.O.P.S.), New York City
EDUCATION	BFA and MFA degrees from Kent State University
EMPLOYMENT	Founder, O.O.P.S.; Design Faculty, School of Visual Arts, New York
DURATION OF REDESIGN	2 days

"Good poster designs have two perspectives..."

BEFORE Paul's feedback

Paul, responding to the poster

"What if the hands were in the shape of a germ culture?"

Bzzzz. I pushed open the door and walked up narrow stairs. At the top I peered into a dark room. "Hello." No response. "Hello, Paul?" "Sorry it's so dark in here," Paul replied, removing a tarp from the window, "We were just doing a photo shoot."

Paul's modest studio produces some of the most recognizable book covers and illustrations for publications like the *New York Times* and *The Atlantic*. His goal is not to expand his business or make bigger profits, rather he aims to do work he's passionate about. This allows him to experiment and explore lots of solutions for clients he wants to work with. He's also managed to teach for many years at the School of Visual Arts.

As I sat down at a small table covered in piles of ties, Paul pinned up my poster. "The quick impact is missing. If people only have a few moments to see this, it has to hit them," he said as he quietly moved toward and away from it. He liked the positive and negative space of the hands but felt they were too light and that the type blended into the image.

"Have you seen the Andy Warhol exhibition?" he asked. "This reminds me of his camouflage work. What if the hands were in the shape of a germ culture?"

"This is hard," he said. Typically Paul suggests directions, lets a designer explore how that might look, and then provides feedback on that. So it seemed natural that he encouraged me to move forward and evolve what I presented.

Paul suggested creating 10 times the number of hands and using an "icky" color palette. He went on to suggest creating a near and far experience for viewers by pushing elements forward and back and playing with levels. He was slow and thoughtful

in his feedback, thinking through his ideas in the course of his conversation.

"Good poster designs have two perspectives, one that you see from a distance and one that you discover as you move closer to it," he said. Paul likes to ask his students to hang their posters up across the street from his 6th Avenue studio to see which ones really work from a distance.

Book cover by Paul Sahre

Paul had an air about him that didn't take design too seriously. He was casual yet specific in his feedback. Some of it was logical, like: "Will someone be able to read this from a distance? And what about when they come up close?" But a lot of his feedback considered ways to present something in a totally new and unexpected way.

I was inspired by the way Paul absorbs the world around him. I left the meeting feeling curious about the ideas we talked about. Wondering about ways to execute a poster covered in hundreds of small hands. I was excited to explore a murky and dirty-looking color palette while creating two levels for the viewer to experience.

I started by filling in the hands with solid greens and browns and multiplying them. I worked through this digitally since I had a clear picture in my mind. As I worked I stepped away from the computer, looking at it from the studio and making sure the form was looking like a germ culture.

Poster by Paul Sahre

Once I had the form of a germ culture worked out on the poster, I played with the color palette and typography. I shifted the way I approached the poster, but used the same elements, evolving them slightly. The result was a totally new poster with two levels to experience.

Illustration by Paul Sahre

PROCESS Exploring color

PROCESS Exploring color

PAUL SAHRE ON DESIGN AND THE WORLD AROUND YOU

Poster by Paul Sahre

Do you have a unique process or a particular way you approach design?
I try to utilize what's around me.

Were you taught a particular process or is this something you developed over time?
I wasn't taught this, it's developed over the years. I got my MFA in Graphic Design so I had lots of time to think about these sorts of things.

If you're stuck on a solution, what do you do?
Sometimes the first idea you have is the best one.

I don't let myself look at something for too long. My eyes go numb.

With illustration work, the deadlines are very fast so we stay focused on what the core message is. We'll ask ourselves, What's the thesis?

"Sometimes the first idea you have is the best one."

And I'll go work on something else and come back to it. It's important to stay really objective about your work; it's the worst when you can't look at it objectively. But I have a lot of tactics that I'll do. I'll look online, or at books, or go for a walk around the block.

How often do you experiment?
I'm always experimenting. I'm always trying different things. As an art director I'll have someone try different things and see what works. I like to change things up and not do the same thing for weeks. Even with teaching I like to try new things and change things up so it stays new for me.

What's the future of design?
I have no idea. I have a really pessimistic and optimistic view of design.

Poster by Paul Sahre

When I look outside I don't see designers having any effect on the visual landscape. And every day there are more and more designers. Today designers are marginalized more than ever.

You look at the Pizza Hut logo or the Red Roof Inn logo and you don't see a designer having any input. But if you look at the design a few years back you can see it.

Today, design is driven by market research and the marketing department. Designers don't have much say in what gets created. But then there are people who are doing great work, so there are two sides to it.

Design is in a weird time right now, it's in a flux. There are many opportunities; you just need to know how to find them.

"Design is in a weird time right now."

Book cover by Paul Sahre

CREATE TWO LEVELS FOR YOUR VIEWER TO EXPERIENCE

Consider an up-close experience and a distant experience. Get inspiration from the world around you. Let recent experiences enter your design process and help shape and influence the work.

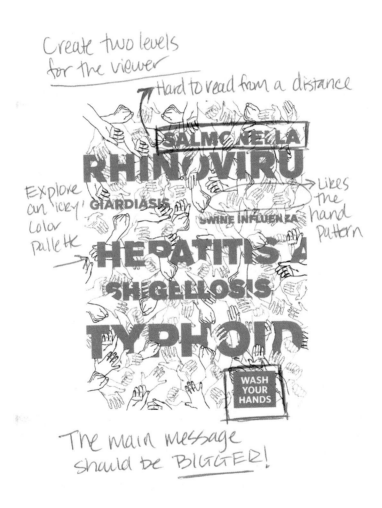

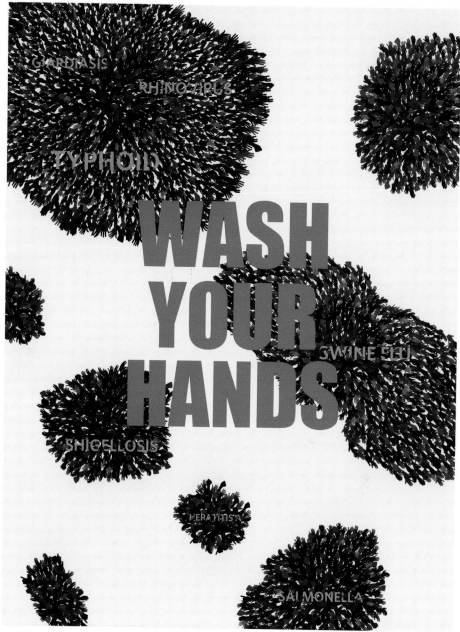

AFTER Paul's feedback

ALICE
TWEMLOW

LOCATION	School of Visual Arts, D-Crit, New York, NY
EDUCATION	BA Bristol University; MA in Design History, Royal College of Art
EMPLOYMENT	Chair of Design Criticism, School of Visual Arts, New York, NY
DURATION OF REDESIGN	5 days

"If you pose it as a question, the answer is wash your hands."

BEFORE Alice's feedback

"Wash your hands? I'd say no. I don't want to."

Alice, responding to the poster

"Have you thought about who would fund these posters? And the distribution system?" As a writer and critic who engages design as a social system, Alice made context the focus.

We sat across from each other in her office at SVA. Alice is a leading voice in design criticism, and she's interested in the contextual aspects of design that most designers tend to overlook.

"If you knew that this was going in a club bathroom in Brooklyn, you could make subtle linguistic and visual references to the locale," she explained. In her view, designers must better understand the way in which their work is disseminated. "Sometimes that dictates the way in which it's displayed, its formats, its positions," she said.

The impact of graphic design also can be influenced and enhanced by understanding the system in which you are working. Alice pointed out that a printed graphic piece becomes more relevant and informative within a larger system of news delivery and communications, like TV or radio.

"If I just heard something on the news that morning and then I saw a poster that emphasized it, that could really have a lot of impact," she said. Alice imagined a database that could customize posters by feeding current facts and taglines into each reprinting.

"There's something visually compelling about this poster. I don't know that I want to muck around with that too much," she said.

However, she described the language as "top-down instructional, slightly anachronistic from an era of WPA posters." For her, the phrase "Wash your hands" was repellent and boring. "Wash your hands? I'd say no. Who says? I don't want to. I was going to before, but now you told me and now I don't want to," she said laughing.

"I think we're at a point now where you could be making a more nuanced and more sophisticated statement about persuading or provoking or joking someone into changing their behavior."

Instead of delivering a command, she proposed asking a question: "If you pose it as a question, the answer is wash your hands. But how could you arrive at that in perhaps a more interesting route?"

Alice tasked me to create a message that was less direct and more nuanced. I was inspired to let the design stay as is and focus only on that language, thereby giving the poster a totally different tone and attitude.

Book by Alice Twemlow

I headed back to my studio and explored how I could pose a question in a specific environment—like a club. Could it be tailored to a Brooklyn women's restroom? I wrote lots of headlines and looked at WPA posters to understand the style of language I wanted to avoid. I considered how restroom posters are currently presented: in stalls, over urinals, in poster frames, and as part of revolving digital posters.

I created lots of iterations of image and language to suit various locations and target viewers. Ultimately, I decided to continue with the existing pattern, since Alice felt it was strong, and focused on posing the language as a question instead of a demand. The result was a small visual shift in the poster's evolution but helped me better understand how the restroom context could influence the design and how subtle shifts in language could completely change a viewer's reaction.

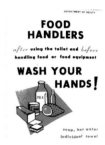

RESEARCH WPA poster

ALICE TWEMLOW ON WRITING AND DESIGN

The decriminalisation of ornament

Article by Alice Twemlow

"I really like a sense of sociability."

Do you have a unique process or a particular way you approach a project?
The first thing I want to do when I'm writing about something is to make sure I have the actual object—that's obviously difficult in the case of a building or a city; but you know, to get close to it in some way and really to spend a long time studying it and just being with it. It's really difficult to write from an image or from memory.

This is something that I've learned from Rick Poynor. He's someone that spends quite a long time describing the object in his writing, and you think, "Why does he do that when there's an image accompanying the article?" But it's actually a really useful process, because through doing that, as a critic, you're framing it a very particular way. You're describing using certain subtle tones which you can come back to. If I have any kind of process it's really getting inside the subject I'm writing about and understanding it on a deep level.

Usually, I want there to be more than one example of what I'm talking about, so I often gather things together. You can see around my room—piles of things. That's what I have in all those file boxes over there. Things that I notice that I like. Things that are intriguing.

At the moment I'm writing about graphic design magazines edited and published by graphic designers. I've been collecting those over time and just figuring out what the similarities are. I do a lot of compare and contrast. I think that's probably at the heart of a lot of process of design criticism.

Then the third part that I always do is look for meaning. I think about what it looks like, is there a movement of some kind that I can actually talk about? And then why would people care? What's the social connection? How does it affect people and why? Is it harmful? Is it beneficial? And I don't do any of that unless I'm intrigued or provoked or attracted in some way.

If you're stuck on a solution, what do you do?
I often just talk it through with someone. Trying to describe your argument to someone really helps.

I'll also go to different environments. I really like working at cafes. As a writer I like a space that's social, where there's a hub of conversation and music in the background. I really like a sense of sociability going on around me.

How often do you experiment or shift the way you think about something?
I'm not that experimental with writing. When I read I do a lot of close analysis of other types of writing. I'm very aware of all the mechanisms and techniques that they're using and I totally admire them. I'm always storing them away, but I rarely use them. It always feels very uncomfortable to me when I start writing in a different voice. It just doesn't fit and I find myself slipping back into my own ways again.

How would you describe your voice?
It's curious. I'm very open to alternative types of design, and that's probably what makes me different from other writers. I'm really interested in what's going on in a subculture level and street level in design just as much as I am by what's at the MoMA.

When I was doing my MA at the Royal College of Art in London one of my essays was about club flyers, which at that time were rising to the surface as a new form of ephemera. If you looked at them critically as pieces of aesthetic you would probably say they're absolutely terrible with awful typography and every cliché you can imagine. But as an artifact it represented a particular moment of London club culture in society. I thought they were absolutely fascinating.

What's the future of design?
I think designers have to really understand the systems to which their work is disseminated. The idea of producing a one-off art object that is somehow going to find its way to its rightful viewer is something that is completely not in our present day or future. And that applies to print-on-demand and all the new mechanisms and distribution systems by which things get out there.

Understanding that if you're designing something for the web it's not necessarily going to be experienced in those little boxes, it may end up on a handheld device or through an RSS feed completely stripped of its design.

Designers are really beginning to battle with the lack of control— when you let go and hand it over to the world. I think it's a very difficult situation for designers or for anyone to deal with.

"It always feels very uncomfortable to me when I start writing in a different voice."

USE LANGUAGE TO PERSUADE AND PROVOKE

Explore the nuances of language and how it can help shape the tone of your design. Think about how language can impel your viewer to change their behavior.

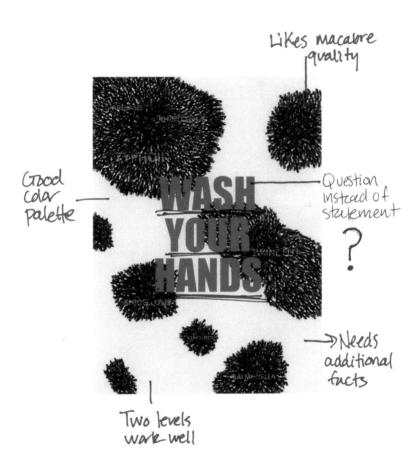

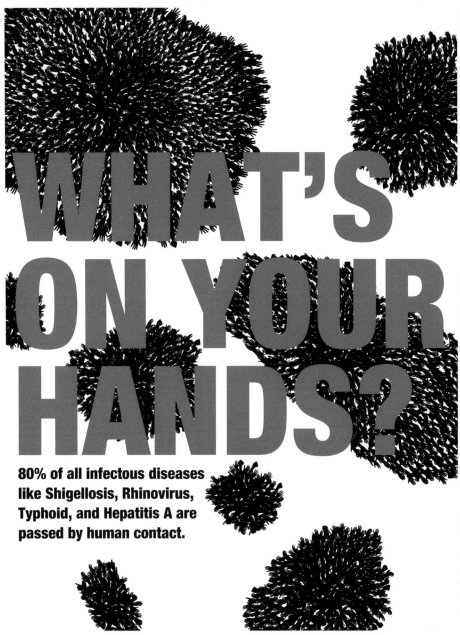

WHAT'S ON YOUR HANDS?

80% of all infectous diseases like Shigellosis, Rhinovirus, Typhoid, and Hepatitis A are passed by human contact.

AFTER Alice's feedback

JESSICA
HELFAND

LOCATION	Yale University, New Haven, CT
EDUCATION	BA Graphic Design and Architectural Theory, Yale; MFA Graphic Design, Yale
EMPLOYMENT	Partner and Co-Founder, Winterhouse Studio; Co-Founder, Design Observer; Faculty, Yale University
DURATION OF REDESIGN	6 days

"You want someone to think, 'Oh shit, I have to wash my hands.'"

BEFORE Jessica's feedback

"Design is improvisation."

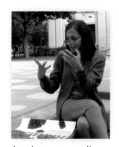

Jessica, responding to the poster

"It should feel visceral and emotional and theatrical," Jessica said, waving her hands in the air.

An hour earlier we met in the dark Sterling Memorial Library at Yale University. We decided to go outside since I would be filming. We walked through the long nave of the Gothic revival building as thousands of stained-glass panes flashed down on us.

"So how many times will you redesign this?" Jessica asked. "And do I get to see all of them?" She seemed excited about the project as we walked quickly looking for a spot to sit outside.

I was nervous. Jessica Helfand is a powerful voice in graphic design. She is a founder of Design Observer; a partner at Winterhouse Studio with her husband, William Drenttel; and a Yale University professor and alumnus.

We sat on a bench in a courtyard. "This is really a great project," Jessica said. It was a warm September afternoon.

I pulled out my latest iteration. Jessica looked at the poster, pulled back slightly, and responded firmly, "I'm of the old-school, Paul Rand view of the poster." She looked at me over the rims of her eyeglasses. "It's the rare time we have the chance to make impact with pure graphic form."

"You want someone to think, 'Oh shit, I have to wash my hands.'" She looked down at her hands and acted out the moment. Jessica proposed an action-oriented poster, visceral enough to make someone wash. The poster was too digitally rendered, she said, and the germ culture didn't read from a distance.

"The illustration looks like a detached piece of cleaning equipment," she said. She encouraged me to get away from the computer, get my hands dirty, and improvise.

"Design is improvisation," she said, shaking her fists. She described her own experience with improvisation while drawing a bird's nest. "It occurred to me one day, drawing the nest, that if I drew the nest the way the bird makes the nest, it would look more like a nest. I just started to draw the lines and started to think about the way they put the twigs together. They go like this and sometimes they go like this, and suddenly it started to have the feeling of a nest." Jessica proposed I do the same and improvise with behaving like bacteria and exploring new materials.

Drawings by Jessica Helfand

"It's an easy thing for you, procedurally, to explore," she said. "You could put your hands in stuff." She described many ways of making forms, while actively performing gestures onto the poster. She talked quickly, sometimes stumbling. "I would encourage you to investigate it two ways. One, open up the investigation formally and just see what that thing could be. Does it repeat? Is it a spore? Is it a cell? Is it a bug? Is it many bugs?"

"What if you started out with a totally clean poster and started putting all the crap on top?" She smacked and smeared her hands against my poster. "Then I would just work out the typography on a white space and do this as a second layer, totally separate, and bring them back together and see how they coalesce."

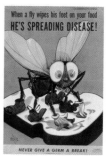

Poster from National Library of Medicine

Jessica paused. She scanned the poster once more and then looked up to me, her glasses slipping down her nose. "I would really blow this thing out. What do you have to lose?"

Jessica's spirit was contagious. Her energy and optimism inspired me to want to go back to the studio and start redesigning immediately. On the train ride home, I watched the video I shot of our meeting and wrote about the experience. I felt completely reinvigorated about my entire project.

Back at my apartment, I pulled out every tool and material I had—paper, charcoal, acrylic, and watercolor paints—and started to explore. I printed out photographs of bacteria and drew by looking and then moved on to creating imaginary forms. I felt free to make things that didn't have to work within a poster. I spent two days playing with materials with no end result in mind. I photographed my hands, smeared my hands over charcoal, dipped my hands in paint, and drew little bugs with ink.

Page from Jessica's book *Scrapbooks*

PROCESS Drawing bugs

Then I examined what I had and developed only the parts I liked. After a couple of days, when I merged the elements together digitally, the poster felt so much more disgusting and gritty. Jessica energized me to improvise, to put my hands in stuff, and to explore the bacterial form before ever touching the computer.

At the same time, her guidance was open-ended enough to empower me as a designer and, ultimately, to express my own creative personality within the redesign.

JESSICA HELFAND ON THE HUMAN TOUCH AND EXPANDING THE FIELD

"...human beings consume design, so why isn't the process full of that?"

Do you have a unique process or approach to design?
Besides making bird nests the way birds make them?

I studied theatre when I was in school, so I find myself drawn to the actual metaphors of choreography and movement. Actual human beings look at posters, and human beings consume design, so why isn't the process full of that? When I went to school it was very Swiss. It was very dogmatic. I feel like I've had to fight for that right. I think your generation, my students now, feel much more open to varied kinds of work.

As time goes on, the balance for me is more into fine art and less into design. So I find that the more time I spend in the studio, the more facile I become in finding new ways to build form in my design studio.

"You learn from looking, and look from making, and make from looking."

So this is something you've developed over time?
Very much over time. There was a period when I was very stuck. The times I've been stuck have been because of technology.

If you're stuck on a solution what do you do?
Write. Draw. Drawing has taught me the more you don't know in your mind what you're going to do, the more it comes out in your hand. You learn from looking, and look from making, and make from looking, and it's all part of this ongoing process.

How often do you experiment?

Daily, hourly. The other day I was incredibly exhausted. I thought, 'I really need the nap and I don't have the energy to draw,' but I sat down in a chair and I drew for 20 minutes. I felt completely reborn. It's so hard because it's a total blank slate every time you start a project; but you look and you think and you reflect and you draw again and you go back to a drawing you made the day before and you go forward and backward. Drawing is really, really important.

How would you describe your voice as a designer?

Classical. I love history. I wrote a book on scrapbooks, and I teach a course on getting students out of the studio and into museums to look at primary sources like letters and journals and books and playing cards and artifacts. It's about really looking at the world before 2010. I have an incredible love for anything historic. I love vintage clothes. I love old movies.

I find it's that theatrical evocation of something that existed before Starbucks or iPhones, before we became homogenized. I love justified type, really classic typography, photography, old photographs. I love things that can evoke a sequence of time.

Book by Jessica Helfand

What's the future of design?

I think the future of design is much more international. Design is much more collaborative than it used to be. All the designers I know, who I respect, are making their own work. They're not waiting for a client to come to them with a problem.

The profession has an incredible opportunity to become something much greater than just commercial art because, let's face it, that's how it started. But I think it really requires a complete 360 on how we educate students and how we think of ourselves. Even if schools aren't able to make the pedagogical shift right away to thinking more broadly and internationally, we can offer exchange programs and travel grants and getting foreign students here. But it's also about learning how to make design more accessible in other parts of the world.

The world needs people to do much greater things, that have to do with people and their needs and education and communication. That's my new crusade. I want to make more things and I want to make things for and with people outside the confines of my practice.

It's a great time to be a designer because it doesn't limit you at all. But you have to think of it as a portal into something much greater than just making a poster or making a brochure.

IMPROVISE WITH DESIGN, BECOME YOUR SUBJECT

Think about becoming your object, whether it's a germ or a character. Draw and write and don't think about the end result. Just free yourself to explore. After a thorough exlporation, pull elements you want to move forward with and start forming them into a layout.

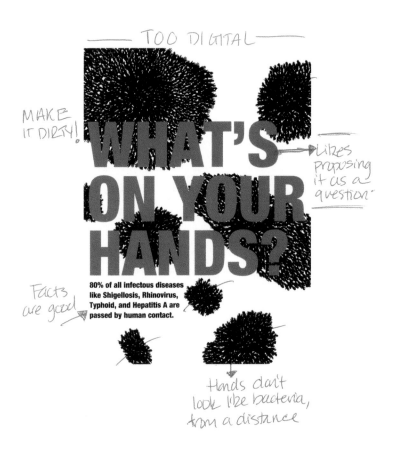

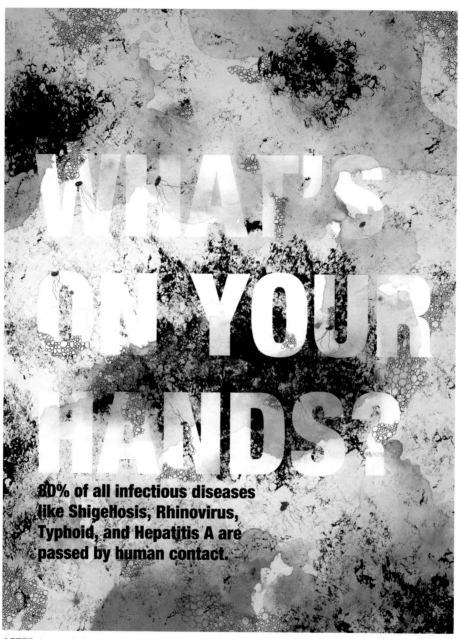

WHAT'S ON YOUR HANDS?

80% of all infectious diseases like ShigeHosis, Rhinovirus, Typhoid, and Hepatitis A are passed by human contact.

AFTER Jessica's feedback

MAIRA
KALMAN

LOCATION	Maira Kalman's home, Greenwich Village, New York, NY
EDUCATION	New York University
EMPLOYMENT	Faculty, School of Visual Arts MFA Designer as Author, New York, NY
DURATION OF REDESIGN	10 days

"It puts you in such an alarming place when you're simply going to wash your hands."

BEFORE Maira's feedback

"Ugh, I think it's really depressing" Maira said, holding the poster out in front of her. "It puts you in such an alarming place when you're just simply going to wash your hands," she explained.

Maira's known for making the banal, everyday moments beautiful. Her illustrations can be found in publications like *The New Yorker*. She's authored and illustrated over a dozen children's books and eight adult books. Her roots in design began when she co-founded M&Co with her late husband, Tibor Kalman.

She was calm and comfortable, welcoming me into her Greenwich Village apartment. I felt at ease as soon as I walked in. "Would you like some tea?" she asked. We sat in her living room drinking tea while I explained my project.

Maira, responding to the poster

"Well, who's your audience?" she asked. "Is this for the Port Authority or a French restaurant, where they're going to say, 'Excuse me'?"

"What about those little reminders we normally see, 'Please Wash Your Hands.' Do you think there's something wrong with those?" I explained that I felt there's an opportunity to be more expressive or more compelling in delivering the message. "Well, you're too compelling here," Maira said. She felt that the poster seemed as though it was designed for a prison, where people were at great risk.

Maira proposed approaching the subject in a gentler way and introducing humor through image or narrative, and questioned why I chose this topic, as well as the effectiveness of hand washing. "Everybody is getting completely crazy. Not that you shouldn't be washful. I mean...I don't know anymore." The absurdity of being

able to stay clean among all the germs we encounter every day drew her in.

Illustration by Maira Kalman

"It could be that you have some kind of narrative that draws people together," she said and then gazed out the window for a few moments. "You know, something like, '53 million people have 80,000 colds a month. Aren't you sick of sneezing?'" she said laughing. Kalman liked the idea of bringing a fictional narrative into the poster.

She proposed enlarging the typhoid bug, "Even if you took this guy and made him big and gave him a name, Mr. Lump-y-cala-boch-olis," she said slowly, making it up as she spoke. For me, this response encapsulated Maira's view of the world. She instantly humanized this little creature I'd drawn, and it was totally natural for her to name it.

Illustration by Maira Kalman

She gazed out the window again. It was quiet. "If I were attacking it, I would start with a beautiful luminous photograph of a pale pink bar of soap," she said. She felt that humor was a better way to communicate a message. "It makes you laugh at the situation," she explained. She came up with many imaginative ideas, all built around a fictional narrative that she spontaneously created.

"Even if you took this guy and gave him a name..."

Maira and I laughed about ideas, about the content, and even about the poster I presented. She let her mind wander as she dreamt of ways to incorporate beauty, narrative, and humor, openly sharing ideas and talking through them, discovering them as she was talking.

I left her apartment inspired to start making; but more importantly, I felt a fascination with her as a person. In just one hour, I became captivated with her imagination and the fantasy she created around hand washing. Her ability to let her mind run wild and openly share her ideas totally inspired me.

Illustration by Maira Kalman

Back at the studio, I set out to draw bugs, make characters, and create a narrative by letting my mind wander and following my instincts. I got lost in the process, playing with all kinds of materials. After a few days I chose to move forward with the typhoid bug portrait. I explored watercolor and pencil treatments, different types of frames, and even names for him.

PROCESS
Photographing soap

MAIRA KALMAN ON DESIGN AND INSTINCT

Illustration by Maira Kalman

"*I try not to think.*"

Illustration by Maira Kalman

"*My instinct is to use my instinct.*"

PROCESS Type and narrative exploration

Do you have a unique process or approach to design?
I try not to think. I try to allow instinctual images to bubble up from nowhere and hope that in sketching I find the direction I want to go.

Is this something that has developed over time or have you always worked this way?
My instinct is to use my instinct. To allow my hand to create images that I'm not expecting. I think it's something that I'm more aware of now—the physical connection to making a line, and how it feels physically to you as an extension onto the piece of paper, as opposed to it being more cerebral. I tend to hope that it comes from some inner stomach place.

How often do you experiment?
I might hand-write or use a typewriter or set type; I might use a pen and ink or paint or write with a pencil, but I'm still within a certain vocabulary of paper and implements to create art on paper. If I do embroideries on fabric, that's another branch of it, but it all seems like the same thing to me. I don't know if I'm experimenting as much as just trying to find my voice.

How do you describe your voice?
I often say I'm not interested in the plot. I'm interested in the subplot and the in-between.

It's a narrative voice, with the need to tell a story that's understood with digressions and the use of peripheral vision to show you what else is going on. The way that I look for my voice is to keep working and to look for things that inspire me. I'm inspired by music, art, architecture, fashion, the street, and literature. I allow those things to enter into my being and find out how I want to tell my story. Dreams, experiences, and my work is very much a journal of my life.

You spend your life figuring out what story you want to tell, and usually it's the same one but you're just shifting the perspective.

What's the future of design?

More stuff. That's all I can imagine. More forks, we need more forks in this world. That's what so wonderful. Things like that keep getting reinvented, the quotidian gets reinvented, and that to me is interesting. Or things that seem supernatural become what you use on a daily basis. So maybe we'll all be flying around on a space shuttle in a few years.

PROCESS
Watercolor texture

BUILD A NARRATIVE AND FOLLOW YOUR INSTINCTS

Use your instinct to write and draw. Think about creating characters or stories. Try ways to deliver your message in a gentle way.

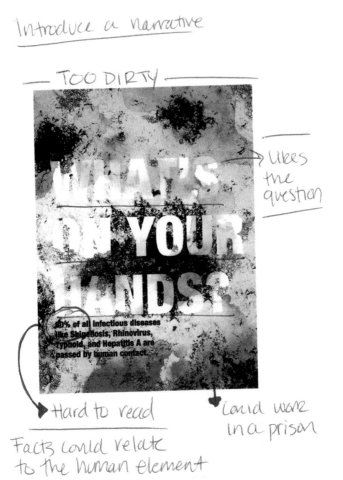

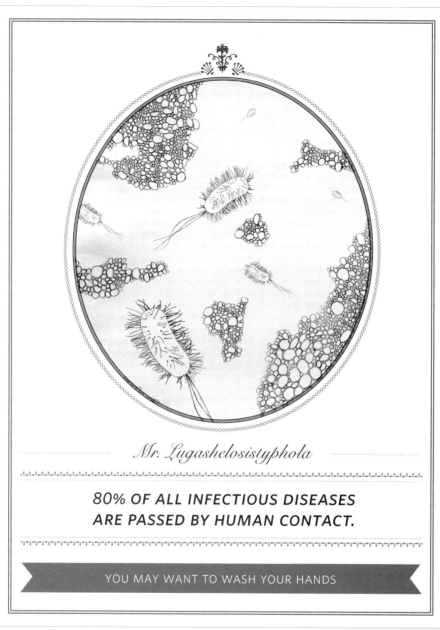

Mr. Lugashelosistyphola

80% OF ALL INFECTIOUS DISEASES ARE PASSED BY HUMAN CONTACT.

YOU MAY WANT TO WASH YOUR HANDS

AFTER Maira's feedback

AXEL
WIEDER

LOCATION Maryland Institute College of Art, Baltimore, MD

EDUCATION BA, University of Cologne; Humboldt University, Berlin

EMPLOYMENT Curator of exhibitions at Arnolfini, Bristol

DURATION OF REDESIGN 6 days

"If the task of the poster is to make people do something, I would like to see this task on the poster."

BEFORE Axel's feedback

"What's the problem you're trying to solve?" Axel asked. He was confused as to why I was even tackling such a poster. "Do people not wash their hands? And do you really think this a problem?" he asked. He interrogated me about the overall concept, sometimes interrupting me midway through my answer. "Is that really the problem you're solving?" he asked. He was soft spoken.

Axel brings a European conceptual arts background to design. As a curator and art historian, he collaborates with designers and artists on exhibitions and books. He also runs Pro qm, a thematic bookstore in Berlin that showcases work relating to politics, economics, architecture, design, art and theory.

Through his work, he often considers the relationship between the work and the viewer. He specializes in conceptual arts and postmodern theory, and his feedback reflected this.

Axel, responding to the poster

From the very beginning of our conversation Axel explained that the poster should be direct and not "trick" the viewer. He thought that the poster should utilize a normative language, "so that everybody will look at the poster and respect the poster."

"What's the reason for the embroidery elements?" he asked. Formally, he thought the decorative elements seemed ironic, and he proposed that the message be stripped down to type and symbols.

It didn't seem to matter what questions I asked or how I answered Axel's questions; he already had a clear idea of what the poster should look like. "If the task of the poster is to make people do something, I would like to see this task on the poster," he said.

While he wanted to see a directly stated message, he also suggested commenting on the power relationship between the poster and the viewer. After looking over the poster for a few moments he looked at me and said, "It should say, 'Please wash your hands. The task of this poster is to make you wash your hands. Please do it so the poster is successful.'" He was blunt, looking at me seriously.

The reflexive approach struck me as just as ironic as using decorative elements. This approach would direct attention to the poster itself and overtly mimic the conventions of signage.

Because Axel was so specific about how he would approach this poster, I wanted to use his language verbatim.

In my view, this was an interesting way of approaching a problem, but I thought it could be off-putting or confusing for the general public. I wasn't inspired to create this simplistic poster based on power relationships. The specificity and directness of his feedback made it hard for me to inject any of my own thinking. I felt restricted and locked into a specific direction.

PLEASE WASH YOUR HANDS.

PROCESS Poster exploration

Pro qm, thematic bookstore, Berlin, 2008. Design: Pro qm.
Photo: Gunter Lepowski

AXEL WIEDER ON DESIGN, TRUST, AND COLLABORATION

Do you have a unique process or a particular way you approach design?
It's research based.

For an exhibition, I'll have an idea or something that interests me, and I start to fully research it and try to set up a possible way to approach it. But usually everything changes and I'm very open to let things evolve. If things change because other people are contributing, that's very welcome.

"I'm very open to let things evolve."

Were you taught a particular process, or is this something you developed over time?
Since I'm educated as an art historian, my process was about very different things. But maybe that's in general the future of art history education, that it's more about a certain methodology. My process developed over time, and it was more shaped by practice.

The way in which you work is something you have to invent. If you are a professional writer or curator or working in museums or universities, that's something that's difficult to teach.

If you're stuck on a solution, what do you do?
Play some music. I'm usually doing many projects at the same time, and I tend to work on other things that are more fun because they're moving faster and smoother, and I really have to force myself to deal with something if it's not working. I'll wait until the time pressure is really getting high and I'll have to come up with a good way to continue working.

So how do you finally motivate yourself?
I actually don't leave the table until the solution's found. I'll force myself. Usually if one's stuck on something, it's often very good to continue going with whatever solution is available. It's just about getting over that point, and usually from my experience, it will go into a good direction. As soon as you're

moving, things start to develop. You should trust your own ideas and the people you're working with. Sometimes it's just about trusting partners and collaborators.

How often do you experiment?
Every day. Every day is full of experiments on every level. I don't really have routines, so I'm very open to change and experimentation. And I also like to eat new stuff and meet new people.

What's the future of design?
That's a very broad question, and I can only answer from a very personal point of view. I would like to see design engaging with the way it approaches problems or deals with things. Reflective within the design itself, a self-reflexive approach.

"The way in which you work is something you have to invent yourself."

TURN DESIGN ON ITSELF

Consider the power relationship between your design and its audience. Try a self-reflexive approach. If your work is asking the viewer to do something, explore ways to directly state the function of the work.

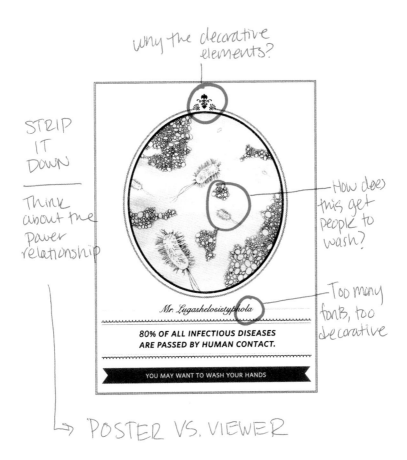

THE TASK OF THIS POSTER IS TO MAKE YOU

WASH YOUR HANDS

PLEASE WASH YOUR HANDS SO THIS POSTER IS SUCCESSFUL.

AFTER Axel's feedback

MICHAEL
BIERUT

LOCATION	Pentagram, New York, NY
EDUCATION	BFA, University of Cincinnati's College of Design Architecture Art and Planning
EMPLOYMENT	Partner, Pentagram; Co-founder Design Observer
DURATION OF REDESIGN	5 days

"I feel like it's too clever. It's meta, it's post-modern. It's self-referential. I get it, but normal people tend not to get it."

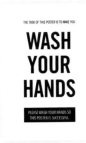

BEFORE Michael's feedback

Michael, responding to the poster

"Bathrooms aren't SoHo galleries with endless fields of white walls awaiting hanging. They have mirrors and soap dispensers and hand driers and paper towels, and all that crap that goes in bathrooms," Michael said. He was annoyed. He looked at the poster with a confused and appalled face. "I feel like it's too clever. It's meta, it's post-modern. It's self-referential. I get it, but normal people tend not to get it," he explained. For Michael a poster like this could easily be interpreted as self-indulgent, irritating, or even wasteful.

"To tell you the truth," he said, looking down at the poster, "I don't think it would work in very many bathrooms on Earth actually... unless it's an art school or some other incredibly cool place." He suggested an empathetic approach by trying to imagine who wouldn't wash their hands.

"I find that people don't actually know why they're supposed to wash their hands—it has to do with germs or something. But do people not wash because they're lazy? Or they don't think it's important?" he asked.

"You know, there are two things I've heard in my life about hand washing that have stuck with me," he said. About 15 years ago he was with his son and was in the habit of washing his hands by only using water. His son told him that if he didn't use soap, he was just pushing germs around. "I've never forgotten that," he said.

More recently, he was listening to the radio with his daughter and learned that you should wash your hands for the equivalent time of singing "Happy Birthday to You" twice.

Looking over the poster again, he glanced back at me said, "I'm thinking it's a text idea. What is it exactly—who knows?" He referenced the empathetic signage on Daniel Pink's Emotionally Intelligent Signage site. Michael encouraged me to think about what would impel viewers to wash hands in a specific situation.

LOOK Campaign,
Michael Bierut,
Pentagram

He talked about one sign on the site that was something like "Children at Play, Please Curb Your Dog." "Whatever it was," he said, "it helps you picture your kid or someone else's kid playing exactly in that poopy spot, and it really does change the way you think."

Michael wondered how this could work in a similar way, "or maybe it could make me smile," he said. Michael brings a sensibility to design that's fun, accessible, and appealing to the average person encountering his work. He had a distinct point of view about how the message should be communicated and what the goals should be. He focused on utility and his own personal experiences.

LOOK Campaign,
Michael Bierut,
Pentagram

As we continued on to the interview, Michael moved away from utility and function and thought about contradicting what you'd expect to see in a bathroom environment.

"What if it were a script? What if it were luscious?" he asked, challenging himself to think about the solution in a different way. "What would the minimum requirements be to get the message across?" He started to loosen up his creativity and freed himself to think about less pragmatic possibilities.

"I don't think it would work in very many bathrooms on Earth actually..."

I was inspired by his upfront and logical approach, but Michael didn't offer a clear-cut direction. Rather, he talked through many ideas and encouraged me to continue with the simplistic, undesigned look of the poster I presented.

"What I like about this is it's sort of a little undesigned; it's very straightforward and doesn't depend on composition, white space, or anything else to carry the day," he said.

I headed back and immediately started writing. I wrote pages of slogans intended to directly engage the viewer by applying empathetic language. After a day of thinking and writing, nothing was working. When I wasn't working on writing, I kept thinking about the stories he had shared about his own hand washing.

LOOK Campaign,
Michael Bierut,
Pentagram

This direction was a fresh departure from the demanding statements I used in previous iterations and was more empathetic to an audience who likely already understood that hand washing is a wise thing to do. I stuck with the simplistic, undesigned style and inserted Michael's story about pushing germs around.

MICHAEL BIERUT ON EMPATHETIC DESIGN

"I don't have self-generated projects in me waiting to get out."

Do you have a unique process or a particular way you approach design?

No. I don't have a unique process. I'm one of those people who really needs a project. I don't have self-generated projects in me waiting to get out.

There's one thing that I tend to find successful: I find that to the degree that I can imagine the typical audience member encountering this bit of communication, the better I am at working out an effective response. The times when I'm really helpless is just when I can't imagine who this is for. I just can't figure it out. You know?

I spend a lot of time working it out in my head and I don't think by sketching, unfortunately. I get a lot of aspects of it fixed in my mind first before I'll actually put something down. For something like this, which I think is really about pure communication first and foremost, you actually need to imagine the audience. You need to imagine the context, the specific situation, the impediments to someone absorbing a message or actually obeying the request, and work out something that responds to that.

AIGA National
Design Counts
Conference poster
Michael Bierut,
Pentagram

Were you taught a particular process, or is this something you developed over time?

No. On the contrary. I was taught a completely different process. My design training was very formalist; it had to do with just simply resolving the compositional elements within an aspect ratio, and that was considered successful.

I spent 10 years working for a designer who I think was very formalist in his approach.

"I don't think by sketching..."

In my job, one of the things I learned was just trying to figure out what form actually made the most sense for the context and the audience. But I think every designer finds their own kind of process.

If you're stuck on a solution, what do you do?

I'll do the obvious thing first, and get it out of the way. Thinking about what actually solves this problem; what's the least I can

do to solve this problem. Then, time and resistant clients help. Almost all my work has clients, and sometimes if something is not working, I'll literally take it to the client and say, "I don't think this is right, but I'm going to show it to you anyway." Their reaction can sometimes really clarify things for me and help me make a little bit of a breakthrough. I'm lucky. I had a couple of projects just recently where the client rejected the first, second, and third solution. But the fourth solution was actually superior to the first three.

"I think every designer finds their own kind of process."

How often do you experiment?

Not as often as I should. I actually have a lot of character flaws, and one of them is that I'm really timid about doing something that I can't do well. I won't get on skates or skis just 'cause I've never learned how to do it well and I just hate the prospect of falling down. I'm getting pretty old, so I really have to try very hard to overcome it. I'd say I compensate by over-thinking everything. Obviously you're supposed to *experiment* to come to a design solution, but I have to admit when I think about it, I'd say it's not actually a word I would ever use to describe any aspect of my process for whatever reason.

LOOK Campaign,
Michael Bierut,
Pentagram

How do you describe your voice in design?

I like big, blunt, obvious things. I like things that have a reason behind them, that normal people, like my mom, can understand—to a certain degree. I like things to be clear and accessible, yet I like them to have a little bit of width, or panache, or a little bit of an arbitrary character, too. I wouldn't say that I'm a pure functionalist by a long shot. I like to figure out a place where function and ingenuity and a little bit of inspiration can all collide.

What's the future of design?

I think the future of design is more and more people considering themselves designers; people who have made design their living, working in an environment where they find themselves collaborating more and developing a whole range of skills that a designer trained 30 years ago wouldn't have ever considered. And I don't mean software programs. And if we're lucky, a world where design becomes broadly defined, becomes more central to the way people consider their lives.

"I like things that have a reason behind them, that normal people, like my mom, can understand..."

DESIGN WITH EMPATHY

Imagine your audience, the specific context, and the impediments to how someone will absorb your message. Think about how this empathetic approach can be delivered through language.

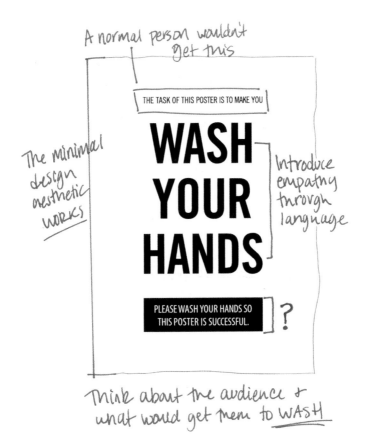

IF YOU DON'T USE SOAP

YOUR'E JUST PUSHING

GERMS

AROUND

USE SOAP AND WASH YOUR HANDS THOROUGHLY.

AFTER Michael's feedback

RICK
VALICENTI

LOCATION	3st, Chicago
EDUCATION	BFA, Bowling Green State University; MFA Photography, University of Iowa
EMPLOYMENT	Principal, 3st, Chicago
DURATION OF REDESIGN	5 days

> *"It's aqua blue with white letters and a blue cross.*
> *And crystal bubbles forming the word soap."*

IF YOU DON'T USE SOAP
YOUR'E JUST PUSHING

GERMS

AROUND

USE SOAP AND WASH YOUR HANDS THOROUGHLY.

BEFORE Rick's feedback

Sketch by Rick Valicenti, 3st

"It's aqua blue with white letters and a blue cross. And crystal bubbles forming the word soap," Rick said, handing me a detailed sketch with a Pantone chip taped to it.

Many years ago, when he "didn't know how to design," Rick called up Michael Vanderbyl in San Francisco and asked if he could visit his studio to see how he works. "There was nothing but a phone, graph paper, a set of colored pencils, and a Pantone book on his desk. I was, like, 'dude, how do you do this?'" Rick said. Michael showed Rick one of his sketches next to the final poster. "I thought, 'Oh my god, that's perfect, what a way to work!'"

Rick claims that it never quite happens that way for him. But for our meeting, he reenacted that experience with Michael. This time I watched him as he sketched.

I was curious how Rick would respond to the poster and what he would propose. I was expecting an experimental approach, something that reflected his personal work. Something crazy. I sat next to him, watching him drawing and talking through ideas.

"This is kind of lame, but it works in a bathroom context," he said. He drew ideas and crossed things out, just thinking through concepts. After 15 minutes he held up a sketch and exclaimed, "I like this. That's it. Done!" Rick handed me a fully fleshed-out sketch with dimensions. It was hard for me to imagine that he didn't always work this way.

"You can get the glass balls at a gift store and just have a lovely light on it," he said. He walked across the studio and came back with an Ed Ruscha book. "I want to find the wet stuff," he said, flipping through the pages until finding a painting with bubbles.

"Look at that," he said, "this is so inspiring. So if you were using bubbles, they would need to look at least that good," he observed while pointing to Ed Ruscha's painting. "Just make sure that the white highlights pop out," he added.

Rick had a childlike giddiness while sketching and flipping through references of Ed's work. He smiled at me and joked, "I know, you fly all this way and all you get is a trip through an Ed Ruscha book." Rick's playful personality and carefree attitude clearly transfers into his work. He's open to trying new things and being influenced by others, and he doesn't take design too seriously.

After giving me a sketch, he talked about where I could find glass balls and how I could photograph them. "You could either Photoshop it or you could put them together. I think it would be better if you photographed them all at once, because there may be some refraction that takes place," he said.

I was excited to create this very specific direction. I didn't need to spend any time working out a concept. I had a clear directive and an order to find clear balls. "Doesn't it look pretty already?" he said, taping the Pantone chip onto the sketch.

Rick doesn't define his voice by adhering to a specific style. He's constantly experimenting, varying the people he collaborates with and the media he works in. This allows him to create work that's constantly changing and evolving. Because of this, it seems as though he can meet any design challenge with solutions that are unlike anything he's created before.

The sketch intrigued me, and the idea of going into the next redesign with a set of parameters allowed me to loosen up and explore materials and photography. The language and colors were defined, now I just needed to execute.

My meeting with Rick allowed me to observe his process, even if he was acting out a scene from many years ago. His laid-back yet incredibly attuned process inspired me to let myself explore, loosen up, and play. "Don't mess it up," he said as I walked out of his studio.

I followed orders and picked up clear balls. I photographed them over text, on their own, and within a range of soft and dramatic lighting. Once I was happy with the photography, I placed the images digitally on top of the type and worked out the overall layout. Paradoxically, the restrictions that Rick defined gave me the freedom to play with ways that the elements could work together in the layout.

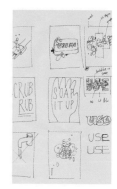

Sketches by Rick Valicenti, 3st

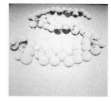

PROCESS
Photographing balls

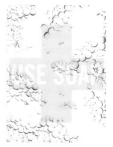

PROCESS Poster iteration

Sketch and Pantone by Rick Valicenti, 3st

RICK VALICENTI ON COLLABORATION AND MAKING

Do you have a unique process or a particular way you approach design?

Yes, the methodology here—unlike what you just saw—is talk, talk, talk. That's really what happens and I'm very conscious of it. At some point the talking morphs into sketching or pushing it around on the computer. And then it goes into question and answer. Like, what if we did this, or are you sure that's making the right statement? And pretty soon we've moved from a conversation into an interrogation, but we're being interrogated by ourselves and answering visually. That's a thing that's easily practiced by yourself and it's easily practiced with others. But for me it's the best way to collaborate.

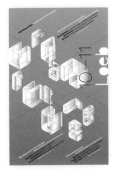

Poster by Rick
Valicenti, 3st

"We just sit and we talk."

Collaboration is tough to begin with because there are two forces are at odds with the process itself. One is of level of politeness, you know? Like, "Uhh, your design sucks." But you don't want to say that, right? So you have to transcend the fear of being honest and being hurt to get to a better place. It's not your place, it's not my place, it's where we push ourselves.

The other thing that's odd about collaboration is the sense of ownership. Who's holding back or ready to pounce with the big idea to stake their claim and say, "That was my idea!" So you have to be open and say, "I have an idea." Great. Have a partial idea or one that catalyzes another. Better. I really admire the people who can push it around together.

Rick Valicenti, 3st

There's also a celebration of work we can do alone. Everyone has a gift—and you want that gift to be present in the studio—everyone is encouraged here to keep making things on their own. I'm always making things.

Were you taught a particular process, or is this something you developed over time?

My exposure to design has been primarily on the job. In my graduate studies in photography, we worked independently. When I'm working on something by myself, it's different from working in the studio as a design director. There you have to engage and embrace things that didn't come from you. That's the space between imposing and inspiring.

"Collaboration is kind of tough..."

If you're stuck on a solution, what do you do?

You just have to check out. You can go to the museum, you can go to the movies, you can do all the normal stuff. The worst place to go is to the annual design books. That to me does nothing but generate anxiety and intimidation inside of me.

How often do you experiment?

All the time. That distinguishes this studio, I think, from others. We're always experimenting with something at some level.

How would you describe your voice?

I think it's quiet. Every time someone like you comes, I'm literally surprised because we can't say we're doing work for any recognizable company. We are at the small strata. No one's asking us to design the Harley-Davidson exhibitions, or an identity for Coors beer, or the cover for the *New Yorker*. We're not on that radar at all. We're just doing design for local stuff and barely do it for the big museums. So it's like a silent voice that somehow has a ripple effect into the community, and I think designers appreciate the practice that's set up here. The practice is a little experimentation and self-funded, self-initiated projects and work for hire. I'm able to make a living, mentor young talent, send them out into the world, and still teach.

What's the future of design?

I have a sense that it's going to change less than we think. In the time that I've been practicing—like 30 years—I have seen things change in the making process and in the distribution process; but for the most part, the delight in the beautiful, meaningful, and resourceful objects is still there. So there's still a need for us to reach out and communicate.

There's always going to be a lust in the experience of holding a really wonderful book, or looking at a beautiful piece of titling design. We're always going to celebrate it, and at that level it's going to be the same. Where it's going to be different is at the level of anonymity and the speed to market. It's getting global.

There's no hydra of good thinking. You can't really say—there's the New York school and there's the L.A. school. There's just stuff, and the stuff is like fireworks responding to the explosion before them. So it's somewhere between new explosions and reverberations of past ones. It's all happening in this really fast cacophony. It's like, "Holy shit! A lot of stuff is going on!"

College for Creative Studies branding, Rick Valicenti, 3st

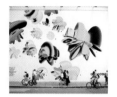

Rick Valicenti, 3st

"The worst place to go is to the annual design books."

CREATE PARAMETERS, THEN EXPERIMENT AND PLAY

Experiment with making form within set parameters. Stick to a concept and allow your-self time to execute the design. Play with various mediums and make lots of iterations.

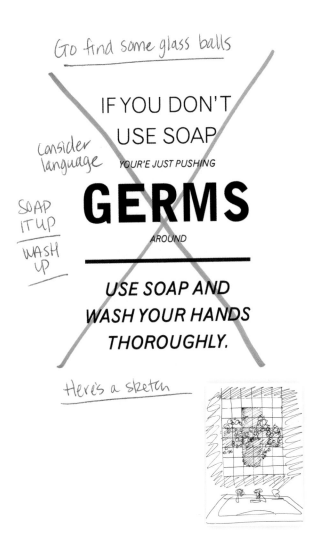

Go find some glass balls

IF YOU DON'T
USE SOAP

Consider language

YOUR'E JUST PUSHING

GERMS

AROUND

SOAP IT UP

WASH UP

USE SOAP AND
WASH YOUR HANDS
THOROUGHLY.

Here's a sketch

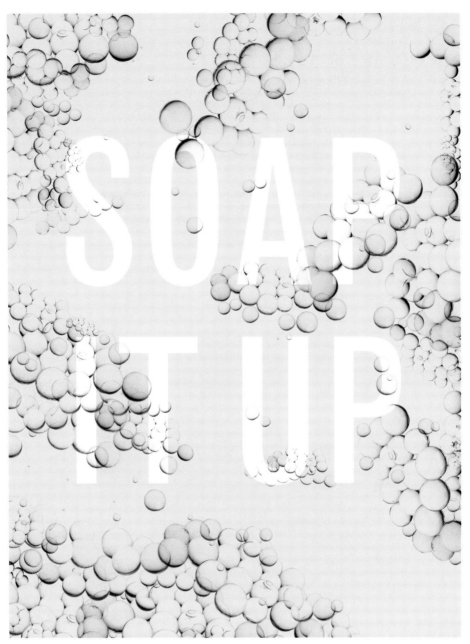

AFTER Rick's feedback

JENNIFER
MORLA

LOCATION	California College of the Arts, San Francisco
EDUCATION	BFA, Massachusetts College of Art
EMPLOYMENT	President and Creative Director, Morla Design, Inc. California College of the Arts Faculty
DURATION OF REDESIGN	3 days

"I think this works well; it has a bit of verve, and that's important."

BEFORE Jennifer's feedback

"Blow it up…"

Jennifer, responding to the poster

"I like it," Jennifer said. "It's out of the ordinary and unexpected for the topic you're addressing." She didn't spend time imagining an audience or analyzing the poster. She responded with her gut. "Blow it up," she said. "If you increase the size of the bubbles, it'll become more graphic." She drew large bubbles with her hand over the poster.

We met at California College of Arts, where she was hanging an exhibition of her work and where she's spent the past few decades teaching. Workers were busy hammering and hanging her work behind us.

Jennifer runs Morla Design, where she works with clients like Apple, Herman Miller, and Design Within Reach. Her work tends to simplify and distill messages while infusing a layer of surprise. Based on her known aesthetic, I imagined she would strip down the poster to its basic elements and then suggest adding something totally unexpected. Her work usually bucks the trend, so I was surprised that she liked the poster and had few suggestions to change it.

She initially focused on the details, like word spacing and the formal layout of the bubbles. Her feedback was minimal. She was terse and somewhat distracted—occasionally looking over her shoulder at the workers installing the exhibition—so I needed to nudge her for more feedback.

"So what about the language?" I asked. "It's good," she said. "It has a play on words, I guess, from a younger audience like, 'Suck

it up,'" she said. She suggested using language that was more pragmatic—like, "Use soap." But ultimately she went back to her initial reaction: "I think this works well; it has a bit of verve, and that's important," she said.

"So how would you approach a problem like this?" I asked.

"Does it need to be a poster?" Jennifer replied. "Yes," I said hesitantly. "Well, I guess it depends on your definition of what a poster is," she responded, adding that a rethinking of what defines a poster was required.

Levi's poster, Jennifer Morla, Morla Design

She suggested that I consider how language functions in a bathroom context, especially in proximity to elements in the bathroom, like a soap dispenser. She imagined simple type on a mirror.

"People love to look at themselves, so with text on a mirror, you'll have a captive audience for your message," she said. She didn't think bubbles were needed to tell the story.

"Does it need to be a poster?"

Jennifer responded in two ways. She gave me feedback on the poster that I presented; but as I nudged her further, she described a totally different approach. While I liked her thinking I wanted to capture her gut reaction to the work. Ultimately, she liked the poster and there was little she would actually change. If I hadn't nudged her, we may have ended the conversation on that.

So I moved forward with her initial reaction in the new iteration. Because her feedback was minimal, I simply made small tweaks: adjusting word spacing and making the bubbles larger. I sent the poster to print and was off to my next meeting with my poster in tow.

Clorox book, Jennifer Morla, Morla Design

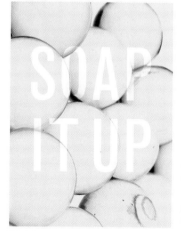

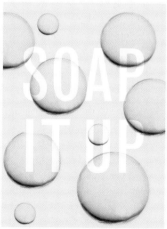

PROCESS Poster iteration

PROCESS Poster iteration

Design Within Reach: Tools for Living Store Graphics, Morla Design

JENNIFER MORLA ON DESIGN AND MISTAKES

Do you have a unique process or a particular way you approach design?

I generate a lot of ideas and always think conceptually about the problem. Ideas are usually easier to generate the older you get because you have more references. You know students have it hard; they don't have as much experience under their belt.

So do you do that by sketching or writing?

Both. A good designer is a great listener, and the client always tells you the solution. You just have to listen for it. By the end of the first meeting with my client I already pretty much know what it's going to be. I don't know actually what methodology I might use for it, but I do conceptually know which direction I'll be going. And I actually throw that out to them just to see if this is going to fly or not. We're interviewing each other, and I'm trying to see how open they are to redefining their category of business.

Were you taught a particular process, or is this something you developed over time?

I was taught this process. I always wanted to be a graphic designer, but for two years I never picked up a pencil. I studied conceptual art at Hartford Art School, and we had to articulate concepts verbally and through installations. That was very important to my growth in terms of generating ideas. Then I graduated from MassArt—studying relatively traditional design—and that's where I really got to express my form and really learn where my strengths were as a designer. I think you learn a lot through collaboration, outside the confines of school. Collaborating with the clients, historians, writers—all this makes for a rich stew at the end.

If you're stuck on a solution, what do you do?

I'm pretty facile at generating ideas at this point. I haven't been stuck in a long time. A very good tool is just to make a decision and stick with it. I really believe in production schedules

Poster by Jennifer Morla, Morla Design

"A good designer is a great listener."

and time management. Time management allows you to accommodate for all aspects of the process, so you're not shortchanging anything.

How often do you experiment?

Every single day. It's totally part of my process. I really believe in being involved in a project from the very beginning to the very end, because only you know what is a mistake, and the best solutions often are a result of mistakes.

How would you describe your voice?

It's appropriate. Stylistically I don't have one approach that I use on everything, because it just wouldn't be appropriate for each client. Once again, our job as designers is to surprise and educate in whatever we're doing. That element of surprise—to turn the ordinary into the extraordinary—should be done on every type of project we're working on.

What's the future of design?

I'll tell you a big one: motion graphics. I really think that with the iPad there's nothing that needs to be static anymore. I think that there's a real tipping point that's happening in design.

"The best solutions often are a result of mistakes."

Poster by Jennifer
Morla, Morla Design

SURPRISE AND EDUCATE YOUR AUDIENCE

Explore how your elements can become more graphic and surprising for the topic you're addressing. Think about how your language can educate and express attitude or verve.

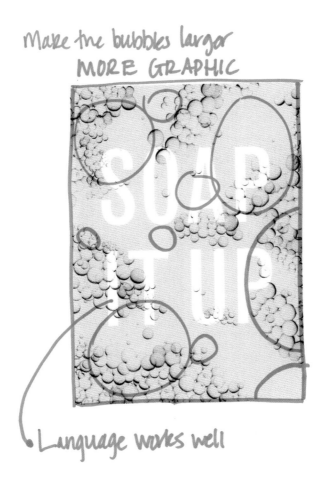

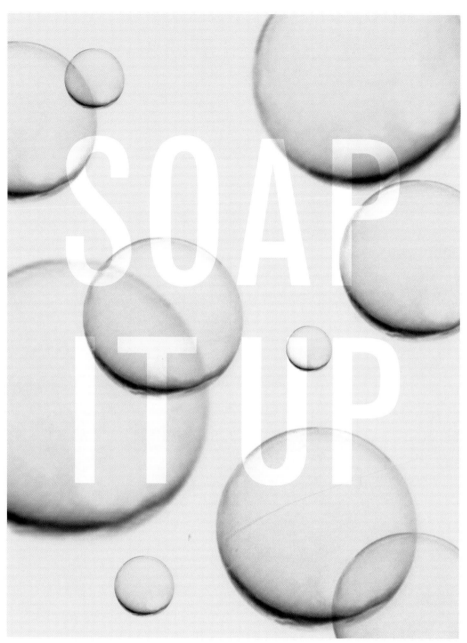

AFTER Jennifer's feedback

MICHAEL
VANDERBYL

LOCATION	Vanderbyl Design, San Francisco, CA
EDUCATION	BFA, California College of Arts and Crafts
EMPLOYMENT	Principal, Vanderbyl Design, San Francisco, CA
DURATION OF REDESIGN	9 days

"Sometimes it's hard to do the obvious thing."

BEFORE Michael's feedback

"This is a designer's nightmare!" Michael said, comparing my project to getting client feedback. He scanned over the poster as his small, circular black glasses slipped down his nose. "It's like when a client says, 'Can you make it more like this?' And you go rework it, and you come back and someone else says, 'Maybe it should be like this,' and you change it. By the third time, you hate the project and just want to put a gun to your head!" Michael joked.

"But it's great. I think you're done," he said looking at me pointedly.

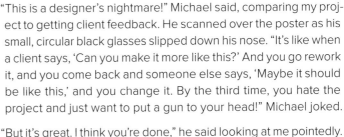

Michael, responding to the poster

His office looked like a high-contrast black-and-white photo. Clean geometric lines symmetrically divided the space, and crisp shadows dropped onto the white walls. I felt like I was meeting with the quintessential design modernist. Michael sat at a huge white desk with a tight grid of books and papers. Two modern lamps framed him symmetrically from behind. He sat back in his chair, relaxed and confident, but not in an arrogant sort of way.

He worked his way through the poster without pause. He liked how the bubbles overlaid the type—a suggestion from Jennifer Morla. Along with Jennifer, Michael also felt that the poster was appropriate for the audience it's addressing. It's no surprise that they had such a similar response. Each began their career around the same time in San Francisco and perhaps came from the same school of thought.

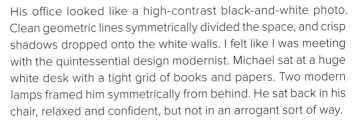

Michael works in a range of media, from identity systems to showrooms and office interiors. He's a self-proclaimed "true modernist" and firmly believes that form follows function. In his process, he usually starts with the obvious.

"Sometimes it's hard to do the obvious thing," he said. He aims for a universal solution and then attempts to turn the personal into something universal by moving in a slightly more abstract direction. He describes his process as working in a reductive way.

Book by Michael Vanderbyl, Vanderbyl Design

His studio embodies the visual language of his work: austere, clear, and stripped down to its bare elements. I expected his feedback to reel the poster back to a more direct point of view. He did suggest visual elements that could make the poster more direct: like using a big bar of soap, or something that deals more with the hand. But ultimately, he retracted and said, "But I like this."

His feedback was minimal, the only element he felt was missing was some type of informational call to action; something someone would read as they moved closer to the poster or while washing their hands. "You could add a small asterisk with a fact about transmitting germs as a secondary thing," he said.

I got the impression that he doesn't work to push the boundaries of design, but he does seek out a solution that works. Then he executes it and moves on. He doesn't overthink anything, or concern himself with embedding layers of meaning. He was sincerely, in this case, trying to get people to wash their hands.

"It's great. I think you're done."

He sat back in his chair, took off his glasses, and looked up at me. "It's good. It's blue, it's water, it's clean. I think you're okay," he said.

MICHAEL VANDERBYL ON LETTING A PROBLEM SOLVE ITSELF

Do you have a unique process or a particular way you approach design?
The problem outlines what the solution should be.

I'm what I consider myself—a true modernist—because I truly believe form follows function. I was educated in that era, and the problem I always had was that what they really meant was that form follows modernism. It doesn't follow function.

Book by Michael Vanderbyl, Vanderbyl Design

So I've always looked at allowing the problem to define its answer. It's like, "What does it need to be?" I'm going to put enough on it myself, just because of who I am and the side of the bed I woke up on. I have a style no matter how hard I try not to. I try to take a cue from the actual project itself, and I let clients try to define what their problem is, not what they need to have done.

Having that, I can go back to them and try to do something that meets their criteria and exceeds the criteria in the sense of thinking about things that they hadn't thought of.

Book by Michael Vanderbyl, Vanderbyl Design

And I know it sounds really boring, but I find that with my clients, if I can get it 90 percent there, then they have to give me 10 percent. And I don't have to explain that 10 percent to them. That small percentage can be something strange and weird and wonderful. It's an approach that has worked very well for a lot of years for many clients. Most of my clients are long term—up to 20 years some of them.

Is this something you learned, or was it taught over time?
My education taught me one thing, but I took exception to what it really meant. For me, it's about letting a problem solve itself.

> *"I have a style no matter how hard I try not to."*

I always tell my clients that I design for my client's client: the person who's actually going to see the poster or use the furniture. It's based on their expectations, not the client's. Sometimes it gets kind of difficult because, unfortunately, a lot of times clients think that buying design is like buying a suit. They want to pick something and then call it done. And it's the opposite of that.

For me, it's what makes design more interesting: When you're not an order taker, but you're someone who gets to sit at the table with the people who are in charge—the president or the person who had the vision for the company—and then try to help them to realize that vision.

The residual effect is that if you do things that work for them, it usually ends up making their bottom line better. That's the best promotion piece you can do.

What's involved in your process?
The great thing about getting older is you don't need to sketch as much.

I think a lot about a project. When I'm stopped out on something, I don't just sit there and keep sketching, I just go and work on something else. Over the years, you build this tremendous backlog of experiences that you've gone through in designing something.

I always find when I'm drawing—I know this sounds very Northern California—it speaks back to you when you know you're in the right place. It's a matter of being the type of designer who can actually listen to the work. It sounds so new age! But the idea is that you separate your personal involvement with it, and come to look at it fresh, like you've never seen the thing that you've just done.

And it's about asking yourself, "Does it meet the criteria that you were set out to do, or have I fallen in love with the process and am I blinded by love?"

So I find over the years that you end up doing a lot of thinking instead of doing a lot of sketching.

PROCESS Exploring a hand illustration

When you're stuck on a solution, what do you do?
The great thing for me is the multidisciplinary aspect of my practice. It makes it more exciting in a sense, because you're not working on the same thing.

I'm not designing an 8.5 by 11 page over and over again, and I can have one medium and one discipline inform another. That keeps me from stalling out on something.

It's like if you're jogging and you come to a stop light. Instead of jogging in place while waiting for the light to change, I just turn and run in another direction.

How often do you experiment?
I try to experiment with every project, but sometimes you can't. Time is money, and it can be your biggest enemy when you're in the part of design that's a business.

I've always been a fan of trying to do stuff where you have to ask, "Is this good or bad?" When you can ask yourself that question, then you know you're still trying. There are plenty of times, when you just settle with solution 23 and, bang, you're done.

I cherish those projects where you have the ability to look at a different vocabulary or a different idea. I love to do that. And I really don't do it very much.

"My education taught me one thing, but I took exception to what it really meant."

We'll look at really humble materials like black AstroTurf and try to actually work them into a very high-end, elegant showroom. And for us, you know, that's sort of the things that are edgier.

I wouldn't call myself an edgy designer. I have reverence for classicism. I would never pretend to be the cutting edge in that sense. But I always try to experiment and push myself.

It's also having the ability to just look around at what's going on. When I teach, it's not necessarily the students' work, but their attitude and hunger that feeds me. It makes me remember that it's exciting.

And when you've had a really bad day with a client and budgets are blown, you just remember that you got in it because you love the work.

Still to this day when I get a printed piece back from the printer, I'll take a copy when I go home at night and just have it on the seat next to me as I'm driving home; and I'll peer over at it as I'm driving. I still have that weird love for it.

Book by Michael Vanderbyl, Vanderbyl Design

I think all of us who are designers are really lucky that we get to do something that is purely our creativity. It didn't exist, and now it exists. And no matter how advanced or forward something is or not, it's still something that you put into the world.

How do you describe your voice in design?
I have a hard time defining my voice. I would say it's a minimalist approach to traditional ideas. I'm a big fan of classic typography and even modernist typography. But I tend to like clarity. I like things that are reductive, but I don't translate that only as being modernism/minimalism. I always love that Coco Chanel quote, "Before you leave the house, look in the mirror and take one thing off."

We're doing a project right now for a winery. The winery is called Checkerboard. So I told the client, "You don't need a name. The label is just a checkerboard, and that's it. There's nothing else on it." And the client was like, "we can't do that." I said, "Well, take this out and ask anybody what is it—a checkerboard. That will give a connection that no one else has."

So if I had a style, it's a reductive one, but I have been told I have a neo-baroque thing too. So who knows? I guess I'm still trying to define that. Leave it to others to define what it is. I have no idea.

What's the future of design?

The advantage of having gray hair is that you see the arc of what's happened.

I think it's a really good time to be a designer, and will continue to be. When I started in the field, you were lucky if anybody even understood what you did. Today design permeates everything we do, and people understand that it's a necessity, not a luxury.

The iPad will change publishing forever. This year we did more films for the web and mobile devices than print. There has never been a better time to be a designer. Print won't go away, it'll just change and evolve. I think books will become even more important as a piece in time about something.

And I think that if we can get past all the MBAs and the whole design-speak and all those people we can get back to being just really good designers who solve problems.

What upsets me is that's what's going to hurt design: this assumption that because you're a designer you don't do strategy. The fact is, any good designer is strategic in how they go about solving the problem. It's like Paul Rand and IBM; he didn't talk about strategy, but he certainly changed the way people thought about corporate identity.

There's still a lot of good designers doing that. Design is in a really strong place and it'll continue to go that way. But I think you have to broaden your definition of what a designer is. You take information and you tell a story, and you convince an audience that this information is pertinent to them. And hopefully in doing that you don't go working for cigarette companies, but you work for companies you believe in. I think that's always been our role.

DO THE OBVIOUS

Think about how you can communicate your message in the simplest way. Strip your work to the bare elements needed to communicate your message. Start simple and build up.

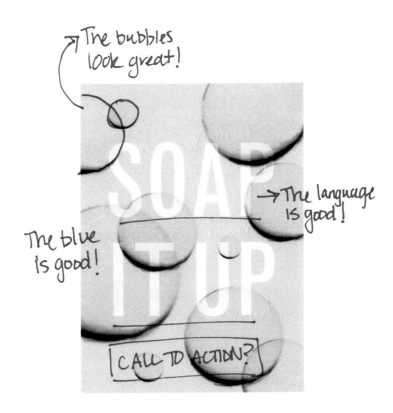

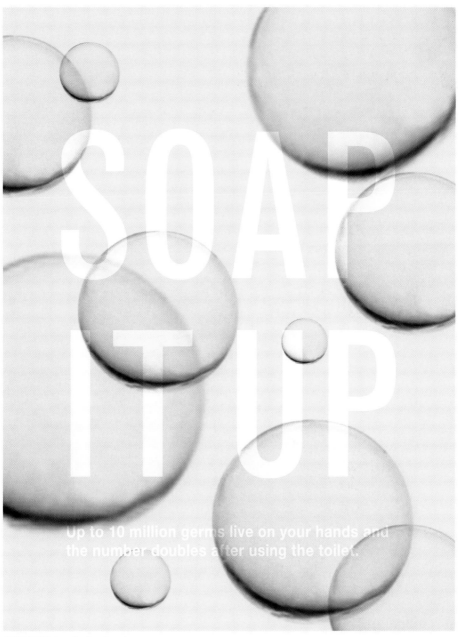

SOAP IT UP

Up to 10 million germs live on your hands and the number doubles after using the toilet.

AFTER Michael's feedback

JASON
MUNN

LOCATION	Jason Munn's home, Oakland, CA
EDUCATION	Madison Technical College, Wisconsin
EMPLOYMENT	Founder, The Small Stakes, Oakland, CA
DURATION OF REDESIGN	2 days

"This could be fun," Jason said, "just to explore what kind of interaction could happen between the type and bubbles."

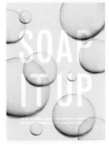

BEFORE Jason's feedback

I stood in front of Jason's home in a hilly suburb of Oakland, California. It was a quiet, misty morning. He opened the door and welcomed me in. His home was minimal and simple. We walked through his living room, turned a corner into a small hallway, and entered his studio—a spare room in his house with a desk and a chair. On the desk were a Mac, pencils, and a sketchbook. His workspace was modest, in many ways reflecting the austerity of his work.

I had no idea what sort of feedback to expect from Jason. Visually, his work is very specific, and I wondered if he would steer me in that direction.

Striking, minimal band posters make up most of Jason's work. His work utilizes a consistent visual language, typically combining images and shapes in interesting ways to create new forms. Many of his posters use elements like records, heads, guitars, feathers, and paint brushes. He masterfully combines images, creating posters that are whimsical and beautiful—evocative of each band.

Because the feedback was minimal in the previous couple of critiques, so were the changes in the poster. I was hoping Jason would prompt a significant visual shift in the poster.

Jason, responding to the poster

From an initial look, Jason didn't get that it was germs or something gross. "It's always tricky," he said, "because you don't want something that's so gross that someone doesn't want to look at it." He stood over the poster and talked through how the type could possibly melt into the background, dissipating where it touches the bubbles.

"This could be fun," Jason said, "just to explore what kind of interaction could happen between the type and bubbles."

"Usually in my own work, I like things really flat," he said. But for this he imagined the type starting out flat and then morphing into something more fluid or dimensional. We both looked down at the poster lying on the floor in front of us. He moved forward and backward from the poster and walked around it, looking at it from all angles.

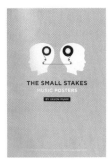

Poster by Jason Munn

Trained at Madison Technical College in Wisconsin, Jason mostly learned the production side of design—like how to set up files, and work in software programs. Because his education didn't emphasize the conceptual side of design, he spent lots of time researching work by designers such as Aesthetic Apparatus and Barney Bubbles. Today, his work can be found in museums and exhibits around the world and has become well-known within the independent music scene.

After studying the poster, Jason quickly came up with many visual solutions that explored the interaction between type and image. He kneeled on the floor, hunched over the poster. "You could get that feeling that it's eating away the germs, but it's not necessarily gross," he said, as his hands skimmed the letterforms.

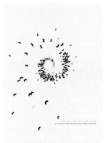

Poster by Jason Munn

"A lot of stuff I do is trying to combine imagery to make something new," he explains. In Jason's design process, he starts with the obvious and writes lists of forms he could work with. He looks at the lists, thinks of the objects as images, and tries to see what the shapes mimic or how they could be combined.

Without overanalyzing his work, Jason simply moves toward ideas that interest him and consistently thinks about pure geometric forms. It's clear that he sees his work as a satisfying artistic expression that he continues to evolve.

Since most of Jason's feedback stemmed directly from the current poster design, I asked him, "How would you design this poster?"

He paused for a moment and replied, "I think I would start with some sort of suds, or those soap dispensers; or there could be a drop of goo or soap, and maybe the type morphs out of the drop. I think that could be something."

While Jason talked through ideas, I also started to think of new ways I could treat the type. I was excited to play with the interaction between the letterforms and the bubbles. This very specific feedback was a manageable challenge to address in a couple of days.

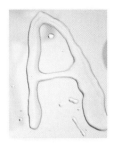

PROCESS Exploring water letterforms

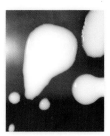

PROCESS Exploring milk forms

I liked the idea of the type dissipating where the bubbles touched it. As I visualized this in my mind, I thought about some of the Ed Ruscha water letterforms that Rick Valicenti pointed me towards.

Back in my studio, I started pouring water on clear Plexiglas, and then pulled the water and drew letters with my finger. I worked quickly to form a few letters, photographed them, and placed them into the poster to see how they were working.

The type looked like it was drawn on a dewy window. The water's transparency made the type hard to read, so I tried using other liquids, like milk and white glue. The white glue gave me control over the form because it dried up after a few minutes.

Initially, I created the entire block of type in liquid form, but Jason had proposed that I focus on the interaction between the type and bubbles. So I removed areas of the liquid letterforms that weren't touching the bubbles. The results looked as though the bubbles were melting away the type.

Jason's feedback was both general and specific. He inspired me to zoom in on a specific interaction of elements while allowing me to explore it visually.

JASON MUNN ON FINDING HIS VOICE

Do you have a unique process or a particular way you approach design?

I tend to lean toward objects, and I'll make lists of things and just look primarily at the shapes of the objects in the list. I feel like I'm always playing some kind of weird mix-and-match game. I'm trying to figure out some puzzle, and sometimes it can be really quick, while other times it's like pulling teeth.

I don't know if it's necessarily unique, but it basically comes down to common sense. Most of the stuff I do is music related, so I'll research the band. But a lot of them I already know fairly well. If I don't, it's like any other project: I look the band up and see what they have going on visually, or look for clues to build off of.

But a lot of times I just find things that seem attractive or something that I want to work with. I think other designers tend to lean toward a mood in music-themed projects, and the mood is something that is hard to capture.

Is this something you learned or was it taught over time?

I went to Madison Technical College. It was a really great starting point for me, and it wasn't high on concept. It was more about getting a fairly solid set of guidelines. It was very production heavy—like getting things ready for print—which is very helpful, but it's not super concept driven.

Some schools focus more on the thinking end and don't really show you how to make it. When I was in school, I was always looking at everything. I was going to the library and getting books, and that's how I gravitated toward more concept-driven work. So I was taught the fundamentals and then you just go where you go and you gravitate toward what you like.

I was trying tons of different styles, and early on, my poster work was all over the place. But you're finding your way until you realize things start to click for you in certain areas and somehow you still can't do that consistently. So I was still all over the place. Eventually you get to a point where you are a little more consistent, but I think it's all just practice and trying different things.

Poster by Jason Munn

"I feel like I'm always playing some kind of weird mix-and-match game."

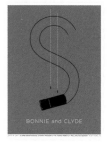

Poster by Jason Munn

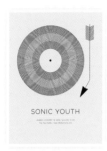

Poster by Jason Munn

Poster by Jason Munn

"I honestly feel like I'm still learning."

If you're stuck on a solution, what do you do?

I'm stuck right now. I work from home so I'm here all the time, but I try to get out a little bit more. I try to make getting away a little bit of a routine. I might walk to the coffee shop and sit there for a few hours and think—not by a computer.

I make note of those moments when I get a better idea and I'm not around the computer. I wish I knew how long it's going to take me to come up with an idea, because I can think about something for days and then it takes me an hour on the computer. It's really about that idea. It's there somewhere; you just don't know when you're going to find it.

I hope at some point to have more of a studio setting or maybe work with a few people. That's the bad part about working alone; you can really get stuck sometimes. Often you just need someone to say one thing and it opens up everything. I'll send stuff back and forth with a couple different people who also work alone and are super helpful. The one thing I miss about school is putting your stuff up and having people see it in a different way.

How often do you experiment?

It usually happens when I'm stuck. Sometimes it will force me to try something new, which sometimes becomes a little difficult for me because people have expectations of me and if I don't give them that they are kind of like, "What is this?"

But that's the thing about doing band posters, too, is that they're fairly low-budget stuff, so sometimes I can try new things and it's not really going to affect very much; but a lot of times, too, I always go back to the bands and if they are more experimental in some way I tend to lean toward that. Because it's more appropriate than if they were a straight pop band or, you know, if they already have some connecting theme throughout their music I don't want to throw them some weird curveball that doesn't make any sense. I don't really appreciate posters that are an image with a name slapped on underneath.

How do you describe your voice in design?

I don't know...quiet.

I honestly feel like I'm still learning. I feel like I'm even in baby stages of trying to make things work. This last year or year and a half I've been the happiest about the work.

I don't know what that means, but even like the first six or so years of making posters I felt like I was all over the place. I was really trying to find my voice, and I now feel like I'm starting to find it a little bit. But at the same time, I don't know if I actually *want* to find it.

I look back on each year and I build off whatever I'm the happiest with and leave behind the others. I just need to keep trying, and I tend to strip things down as much as I can; and that's kind of been the overall line in the work.

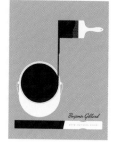

Poster by Jason Munn

I just want to do good work, and I don't really want to think about it beyond that. I don't even know if it's necessarily *good* work. I just want to make work that I'm happy with. I'm not necessarily trying to change the world through design.

What's the future of design?

I could answer that in a lot of different ways. The biggest answer is: I don't know.

What I think is interesting is that there's just so much, and for me it's overwhelming. If I see myself as a designer in this world where everyone is a designer, it's exhausting for me to think about. It's probably exhausting for you to think about.

There are all these websites and a constant bombardment of stuff. About a year ago, I started to shut down from all that. Sometimes you just look at stuff and you get caught up, and I feel like that was taking away from my own work or my own view.

A big change I see is that there are a lot more individuals working on their own and not *for* anybody. I've been out of school for 10 years. In those days, there was not even a thought in my mind to be on my own. I just wanted to work for someone and learn. But I think a design career is very different now.

EXPLORE AN INTERACTION BETWEEN TWO FORMS

Think about how elements in your work interact with each other. Can one element affect another? What happens when they touch? Focus in on the interaction of two specific elements and explore what that morphing or blending could look like.

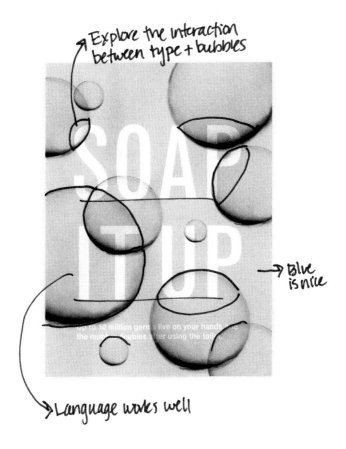

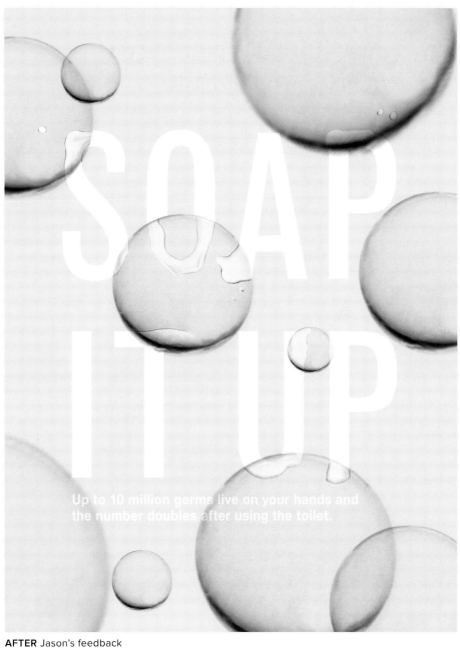

SOAP
IT UP

Up to 10 million germs live on your hands and the number doubles after using the toilet.

AFTER Jason's feedback

STEFAN
SAGMEISTER

LOCATION	Sagmeister & Walsh Inc., New York, NY
EDUCATION	MFA and BA, University of Applied Arts, Vienna; MS, Pratt Institute
EMPLOYMENT	Principal, Sagmeister & Walsh, New York, NY
DURATION OF REDESIGN	2 days

"If you're going to do simple, be extreme about it."

BEFORE Stefan's feedback

Stefan, responding to the poster

I arrived at the Sagmeister & Walsh studio on a "salon night." Each month, Stefan welcomes a group of designers to share and critique their work in a casual group format. I was led into a small discussion room, and three others followed behind. We sat waiting and talking about the work we were going to show. Everyone seemed really nervous. After meeting with 11 other designers for critiques, I could feel the difference between my comfort level and their anxiety.

One of the studio's interns set up our meeting, so Sagmeister didn't know the details of my project. I was hoping he would respond well and take interest in the project.

He came in, sat down, and ate a few snacks. "Welcome," he said. After we introduced ourselves, Sagmeister asked the designer to his right to show his work. Hands trembled as the designer struggled to play a video on his laptop. Then, the next designer fumbled through sheets of paper sketches. I wasn't sure if they were just nervous, or unprepared to show their work.

Finally, it was my turn. I quickly outlined my project and explained that I had a poster to share rather than a portfolio. Thankfully, Stefan responded well.

"Excellent, nice project," he said. "It seems like it's a lot of fun to do. You know, traveling around and interviewing designers on this one very specific thing."

I felt a sense of relief. "So imagine this in the context of the bathroom," I said to the group as I unrolled and held up the poster.

Initially Stefan felt that the bubbles didn't appear soap-bubbly, but looked more like lenses. But ultimately, he decided that it didn't matter because "Soap It Up" was so big. He liked the large

type, but wasn't crazy about the small type. "It's just formatting; the flush left is fine, but the way this P goes in seems a little bit uncomfortable."

Stefan talked through elements of the poster he liked, while following up with, "But I'm not sure it's the best."

He questioned everything, even the things he liked, such as the "Soap It Up" line. He also wondered if it could be a smaller element that you would see in a urinal or toilet. He felt that the space above a sink should be a mirror, and if you want to put something above the sink, it should be incorporated into the mirror. And then he characteristically asked, "But is the space above the sink really the best?"

Installation by
Stefan Sagmeister

"You could design a mirror," he said. "It could be the frame of the mirror or a really small area of the mirror." Because Wash Your Hands was such a simple message to communicate, he felt it could be very small and still make its point. In general, Sagmeister suggested a closer look at the bathroom environment and how signage could be presented in that space.

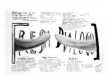

Poster by Stefan
Sagmeister

"There are so many spaces where people look in a bathroom that aren't utilized," he explained. He referenced a photo a friend recently sent him, where a sign next to the urinals read, "Please don't eat the urinal cakes." "It's one of the better designs I've seen," he said laughing, sitting back with his arms crossed. "Be extreme," he said.

For me, this encapsulated his entire design approach. Stefan's work never lies in any middle ground; it's always on the extreme edge of something.

"But is the space above the sink really the best?"

"If you're going to do simple, be extreme about it," he said. He felt that a message as simple as this required an extremely simple approach.

"If I were to design this poster, I would think about something humorous," he said. "There's all sorts of bathroom humor that could be used." His goal would be to make someone laugh or convey the message so engagingly that he would come out of the bathroom and tell his friends about the bathroom experience.

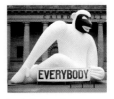

Installation by
Stefan Sagmeister

"I'm not even sure if that's possible. It would have to be a really damn good idea," he said.

Toward the end of our meeting, the group asked questions about how the poster had evolved, if I set up any rules for the project, and what the original poster looked like.

Poster by Stefan
Sagmeister

"That's a great sign if people are already asking you how the poster looked before. It's a great sign that what you're doing is interesting, and that's basically at the very, very core of everything that we do," Stefan said.

I felt a huge push of encouragement after hearing Stefan's thoughts on my project. He offered a few clear directions, and I was excited to explore how I could inject humor into one concept and how a mirror could function as a poster.

Because one of my ground rules was that the poster format must stay 18"x 24", I couldn't explore the idea of making it smaller and harder hitting. Although, I very much agreed that this direction made sense for a bathroom context, I struggled to follow the rules I had established. Ultimately, I felt that staying with a consistent size allowed me to focus on the concept and execution, rather than the medium and format.

Poster by Stefan
Sagmeister

I headed back to the studio excited and inspired. I spent the first day researching bathroom humor and looking into mirrors. The bathroom humor was more focused on men's bathroom experiences. So I started sketching ideas for typographic solutions on a mirror.

I wanted to embrace Stefan's ethos of being extreme. I tried super simple, small sans serif type on the top half of a mirror. The mirror could be placed in a bathroom stall or above a urinal. This was a total departure from the poster Rick directed and in a different medium. As I expected, Stefan shook things up and pushed the poster in a totally new direction.

STEFAN SAGMEISTER ON DESIGN AND SPONTANEITY

Do you have a unique process or a particular way you approach design?
I don't think it's unique. So the quick answer would be no.

I think one thing we do quite a bit is starting from somewhere that has nothing to do with the project at hand. For example, if I had to design a new Diet Coke can we might go look at the

competition and see what's possible with aluminum and see what everyone else does with aluminum.

We would look to see if there are alternatives. And maybe ask my mother, my niece, and 100,000 other people what their experience is.

But then we might start by looking at this cable [he picked up a laptop charger from the floor] and think, "I don't know. Can we do something electric? Can we do something that's very long?" Or maybe it's a hose, one gigantic straw that you suck out of. Not a bad idea. It's possible. I don't know if it's doable, but I definitely wouldn't have thought of it without the cable lying around here.

I think that actually could be possible. [Coca-Cola] is probably too large a company to go for it, but [it could be] a small soft drink in a container that is basically just a straw and you suck it all out.

This process works the best in front of an audience. Strangely if you just do it often and spontaneously, quite often some good stuff comes out of it.

So that's a process—but it's not my process. That's a process recommended by a philosopher called Edward de Bono in a book called "The Five-day Course in Thinking."

Installation by Stefan Sagmeister

"This process works the best in front of an audience."

When you're stuck on a solution, what do you do?
Change. We always have about a dozen projects going on, not all of them in concept stage; but there's always three or four things in concept stage, so I just jump from one to the other.

How often do you experiment?
Every seven years for one year.

How would you describe your voice in design?
Subjective. Hand-made.

What's the future of graphic design?
It's bright and shiny. Mostly because the definition of what design might be becomes so much larger.

I think the boredom that came up on us through technology will hopefully be diversified by the incredible amount of projects we can be involved in. Even if you look only at this office, within a week we might do furniture, documentary film, branding... it's pretty wide.

Video by Stefan Sagmeister

BE EXTREME

Look at all aspects of the environment you're working in and question everything. Whether you're extremely simple or extremely outrageous, push your concept all the way to its edge.

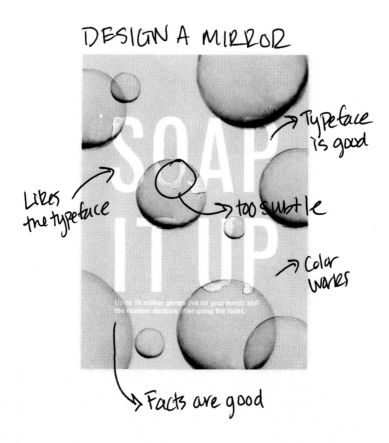

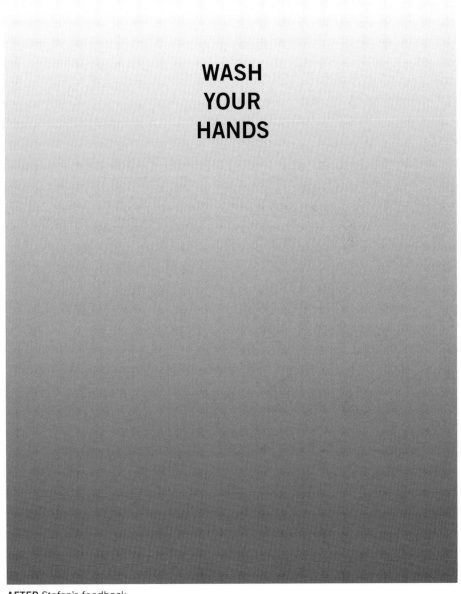

WASH
YOUR
HANDS

AFTER Stefan's feedback

RODRIGO
CORRAL

LOCATION	Rodrigo Corral's studio, New York, NY
EDUCATION	BFA School of Visual Arts, New York, NY
EMPLOYMENT	Founder, Rodrigo Corral Studio, New York, NY
DURATION OF REDESIGN	2 days

"I would want to make it a functional piece of art."

WASH
YOUR
HANDS

BEFORE Rodrigo's feedback

"I love it. It's very cool."

My bus ride to Rodrigo Corral's studio wasn't the typical NYC commute—this time I was schlepping an oversized portfolio. I held on to the 18" x 24" mirror, desperately hoping that it wouldn't break along the way.

Each bump on the bus made me nervous, and I was just as nervous about presenting this simplistic, minimal poster to Rodrigo. I hoped he would see my mirror poster not as too simplistic, but rather as a blank slate offering him the freedom to start fresh and think up a poster from barely anything.

Rodrigo welcomed me into his office/studio, a room separate from his larger studio where three other designers were working. A wall of books stood opposite a wall covered with tacked-up drawings and tear sheets. The studio was messy. Piles of books were stacked on the floor, laid open and strewn about. There were even a couple of basketballs lying around. I sat down in a small wooden chair.

While Rodrigo stepped out for a moment, I looked around and took in the space. I thought to myself, "This is what I want my studio to feel like."

Rodrigo runs his own studio, focusing on book covers and editorial illustrations. He produces covers for some of the best-known authors, such as Chuck Palahniuk and Junot Díaz. Over the past 15 years he has designed more than 500 book covers.

When he returned, I quickly described my project. "Ex-ce-llent," he said slowly, with an amused expression. He asked about the details of the project: how long I had to redesign each poster, who I'd met so far, how many posters I'd make, where I was traveling, and so on. After talking about the project for a bit, I pulled out

Rodrigo, responding to the poster

the large, heavy mirror, noting that while all the other posters were printed pieces, this one was a bit different.

"I love it. It's very cool," Rodrigo said. He explained that he was recently in a bathroom where a large seamless mirror had "Wash Your Hands" markered onto the glass. "I liked that it wasn't your standard plaque over to the side," he said. For this poster, he loved that it was on the glass, where people would look into it. "Every bathroom has a mirror and everybody manages to check themselves before they leave," he said.

Spread design by
Rodrigo Corral

Since he liked the poster so much, I needed to tease more out of him. So I explained that for the redesign I would be interested in how he would design or approach this poster. "So what would you do differently?" I asked.

"I don't know. I'd like to believe I could come up with something as good as this," he said. He sat looking over and into the mirror. It was quiet. He leaned back in his chair and spun in a slow circle, looking up, "Hmmm."

Spread design by
Rodrigo Corral

Slowly spinning back to his starting point, he said, "I keep thinking about how all bathrooms have some kind of writing on the walls." He imagined a bathroom wallpapered with writing. At first glance, it would feel like a typical Lower East Side bathroom, with graffiti and stickers plastering the walls. But as you move in closer, they would all say "wash your hands."

He looked at me intently. "It could be something that looks like it was scrawled by millions of different people," he said slowly. He seemed excited about the idea, and I was too. As he described it to me, I had already started to visualize the poster. In my mind, I saw the wall of a dive bar plastered in graffiti.

Spread design by
Rodrigo Corral

"I would want to make it a functional piece of art," he said. He proposed thinking about how to create a decorative element while still communicating the message.

"So wait, you're actually going to make what I was just describing?" he asked.

"Yeah," I replied.

"How are you going to pull that off?"

He encouraged me to spend some time in bathrooms in bars and restaurants near his studio and photograph the walls. I was intrigued by the challenge, and not being familiar with the area, I was ready to explore. Luckily, I had my camera in hand, so I headed to the streets to find the writing on the wall.

Cover design by
Rodrigo Corral

Cover design by
Rodrigo Corral

With only about an hour to capture as many images as I could, I photographed graffiti on the exterior of buildings and inside a few bathrooms. It was noon, so only a few places were open.

On my way back home on the bus, I journaled about the meeting and felt a sense of ease in starting up this redesign. I had a clear direction to follow, and I was excited about how different this iteration could be.

When I arrived back at the studio, I started sketching different type styles. Since the concept required the wallpaper to look like the scrawl of different people, I asked a few people to write "Wash Your Hands" in their own styles.

I tried to use a range of materials, from paint markers to pens and spray paint. This added to the diversity and energy of the poster. It really did feel like many people made it.

The final poster felt young and energetic, especially compared to past iterations. In this poster I didn't focus too much on formal design; instead I looked at how I could evoke a mood and quietly inspire someone to wash his hands. Similar to what Rodrigo liked in Sagmeister's poster, this poster cleverly uses what's already found in a bathroom environment, embraces it, and redesigns it.

RODRIGO CORRAL ON DESIGN AND OPTIMISM

"To describe process beyond that makes me uncomfortable."

Do you have a unique process or a particular way you approach design?
Since I do a lot of editorial-based projects—whether creating an illustration for an article for the *New York Times* or a novel—it's first reading the text and seeing what jumps out. To describe process beyond that makes me uncomfortable. It changes from project to project. I'd be full of contradictions anyway.

It does involve reading as much as you possibly can, researching, asking how relevant it is to the story. I also could describe it as how an actor reads a screenplay to try to get into it—that's about as much as I can describe.

If you're stuck on a solution, what do you do?

I try not to think about it for a while. Generally, when I leave the studio and walk home, I'll think of an idea. It's happened too many times that I've tried to spend too much time researching, hoping for something to spark, and it's really about just relaxing that part of your brain.

How often do you experiment?

That could be every day. Maybe it's never, maybe it's always the same. I'd like to think it's every day, because we don't work in a style and we're always trying a lot of different things.

I guess if you asked, how often do you just come up with a visual that doesn't solve the problem—that would be experimenting to me. That would be really experimenting.

But I just started experimenting with not having a large computer in front of me for the last month in the studio space, and we just pin up things that are inspiring, just to give myself a break. So that is a way of experimenting.

How would you describe your voice in design?

Gobbledygook.

Because it's always changing?

I'd like to think so. And evolving.

What's the future of graphic design?

I don't know the answer to that question.

I still feel really optimistic about books. The National Book Awards was last night, and this woman said in her acceptance speech, "If there's one object we shouldn't allow to ever go away, it's books." Something along those lines. It's true. I don't see books ultimately going anywhere. I think it's just forcing publishers to make better decisions with what they choose to publish.

Up until maybe five years ago, publishers put out as many things as they could until something stuck. But that's changed and now publishers are looking much more carefully. It's definitely tougher for book cover designers. So designers have to work even harder to convince me, convince the publisher, and convince the author, why this is a good jacket cover.

> *"It's really about just relaxing that part of your brain."*

Cover design by
Rodrigo Corral

CREATE FUNCTIONAL ART

Think about the context you're designing for, and try mixing function and art to create something surprising. Spend time researching the area you're working in, and pull inspiration from everywhere.

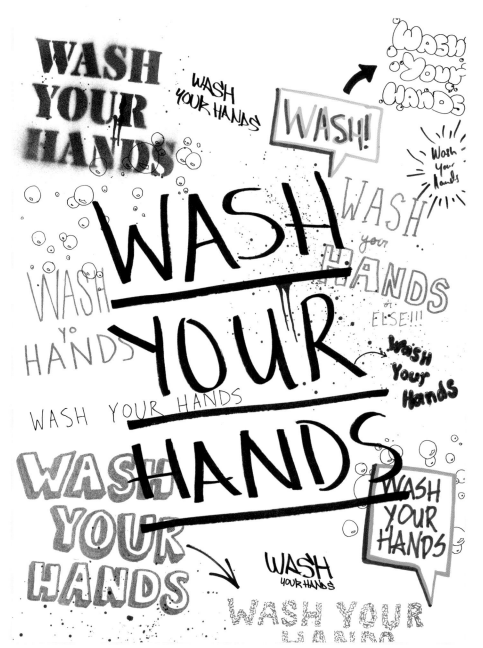

AFTER Rodrigo's feedback

DEANNE
CHEUK

LOCATION Henri Bendel Offices, New York, NY

EDUCATION Curtin University, Australia; BA, Curtin University

EMPLOYMENT Henri Bendel, New York, NY

DURATION OF 2 days
REDESIGN

"I definitely think there's a difference between designs that come from men and designs that come from women."

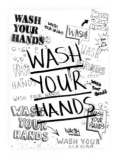

BEFORE Deanne's feedback

"Let me guess. The designer before me was a guy?" Deanne asked. She instantly responded to the poster aesthetically and thought it felt young and masculine.

Deanne and I met at the corporate offices of Henri Bendel, an upscale fashion retailer. She greeted me in an enormous waiting area that could've housed four of the previous studios I had visited. We walked down a few hallways, getting glimpses into identical offices and making a few turns as Deanne asked me about my trip up to New York. We walked into her office and she sat down behind her desk. I pulled out my poster and set up my camera, but Deanne hesitantly said, "I'd prefer if you didn't film me." I pointed my camera to the floor and told her I would just record the audio.

An hour earlier I had been on the bus, excited for our meeting. I'd admired her work even before I started doing design. I remembered being mesmerized by her illustrations in *Tokion* magazine in 2002. I imagined her guiding me toward a more illustrative, maybe even hand-drawn solution and responding well to all the hand-crafted type in the current poster.

Illustration by Deanne Cheuk

I unrolled the poster onto her desk and summarized my project. She wanted to know more about the process behind the poster.

"Is the lettering written on the poster, or is this a printout?" she asked. I explained that the poster was a printed composite of many files. I talked through the process of drawing hundreds of Wash Your Hands, making stencils, and exploring materials. I also mentioned that multiple designers took part in creating the hand-drawn type. "Wow, that's great," she said.

"I think I'm just a bit overwhelmed by the main font usage," she said. I explained that I wanted to create a sense of hierarchy so someone could quickly get the message. She didn't mind the placement, but she didn't like the masculine feeling of the type.

Her initial reaction to the poster surprised me. So far, no designer had reacted so specifically on the feminine/masculine quality of the work.

"I think this type looks great and I think these are really cute" she said, pointing to different areas of the poster. She seemed uncomfortable telling me what to do next or what to focus on in the next iteration.

"This is just so subjective," she said. I wasn't sure how to respond to her comment. This was, after all, the whole point of my project. Quiet and deliberate in her feedback, she continued to focus on the masculine quality of the poster.

"I definitely think there's a difference between designs that come from men and designs that come from women. I can usually tell." She describes work that she likes as, "feminine, beautiful, and pretty." As she described her view of feminine design, I thought about how I respond to that aspect of design. Unless a design is overtly feminine or masculine, it's not a quality in design I imme- diately think about. "What do you think of it?" she asked. I didn't want to say too much, so I reminded her that I was designing this poster based on a conversation and really trying to reflect the feedback I received in the poster. "You must have personal preferences," she insisted. I tried to sidestep the question, re- explaining the concept of the project.

"Well, this spray-stencil one looks great," she said. She suggested taking just the stencil type and blowing it up large, placing it at an angle, and introducing a color gradient to the existing paint texture. "I would remove the drips and add a few paint splatters," she said. She liked that the stencil harkened back to signage and thought it was more expected for a bathroom environment. She went from being unsure about how she wanted to respond, to giving specific directives.

Midway through our conversation, she pulled back and held up the poster. "I think this poster could totally work in a bathroom. It's definitely eye-catching, and it's clever because you don't really see graffiti in modern-day bathrooms anymore," she said. She thought this poster would make you stop and think "Wow, what's that?" This opinion was totally contrary to her initial reaction.

Illustration by
Deanne Cheuk

"This is just so subjective."

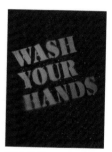

PROCESS Exploring
color

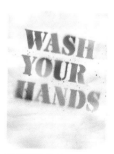

PROCESS Exploring
color

Illustration by
Deanne Cheuk

Illustration by
Deanne Cheuk

Illustration by
Deanne Cheuk

"I don't sketch."

Deanne didn't question the format, the medium, or the language. She strictly focused on the visual expression and how it could be more feminine and pretty. This focused view allowed me to explore the visual treatment in a very specific way.

I started the redesign by removing all the elements, except for the stenciled, spray-painted ones. I followed her suggestions, literally by removing the paint drips and keeping the type on an angle. I further explored a range of color gradients, while staying in a warm, feminine color family.

The process was about exploring a visual language rather than thinking about how this poster would function in the world. I kept thinking back to Deanne's comment about the poster feeling young. To me, this iteration of the poster felt even younger. I struggled with balancing Deanne's advice and creating a poster I was satisfied with. As my deadline approached, I rolled up the poster, feeling uneasy about taking it to the next designer.

DEANNE CHEUK ON FEMININE DESIGN

Illustration by
Deanne Cheuk

Illustration by
Deanne Cheuk

Do you have a unique process, or a particular way you approach design?
I start with the brief and then I ask questions. If the brief is thorough enough, the design just comes from it. Usually my clients are specific about how something has to look.

How do you begin the visualizing? Do you sketch?
I don't sketch. I go straight to the computer.

With illustration, a lot of my work starts with paper and pencil, and then it gets filled out in Photoshop. So I can sometimes send the client the pencil outline before it's all filled out in Photoshop. But often I don't like to do that, because it's not going to look like the finished product. Sometimes it's easier to just send them a finished product and hope that they don't want to change it.

If you're stuck on a solution, what do you do?
I'll work on something else and come back to it. It doesn't happen to me very often. I'm always working on so many different things at once. There's often not enough time to be stuck on

something. The things I get stuck on are personal projects, like my own career.

I'm such a Graphic Designer because I like to be told what to do. I like to be given the brief. When it comes to being an artist, there's such an open brief. There's just so many options, and sometimes I feel like I don't know what I want to do because there are too many options. That comes with experience.

I feel like I'm just starting out as an artist, and the longer I do it the easier it will become for me. But a good way to deal with getting stuck with work is just looking at books or magazines or the Internet; there's so much inspiration out there.

How often do you experiment?
I'd like to say, "All the time," just because I get bored with doing the same thing over and over. So I try to do it a little bit differently each time. Or if the client says we want it to look like this, I will try to take it a little bit further.

I feel like that's how my work has grown. I've been working for 17 years, and I feel like each year it changes a little bit, but it still keeps a bit of that style.

How would you describe your voice in design?
Feminine. There are a lot of successful female designers, not as many as males. So I would hope that one day I'd be considered to be one of the known female designers. I feel like my voice is just for female designers.

What's the future of graphic design?
The more it moves forward, the more it stays the same.

Recently, I saw a really great panel discussion with Erik Spiekermann. I feel like his work is so classic and still looks so modern; and even though people try to bring in new trends like hand-drawn type or folky illustrations, it still isn't something that hasn't been done before.

I still feel like graphic design has its roots and it's something that people will always go back to. I don't think there's one particular way that it's heading.

Even the new hot type designers have derivative work, or it's work that I've seen before. Even if they are doing their own take, it's not necessarily that new. Photoshop has changed the look of illustrations a lot. So maybe things become smoother, cleaner.

Illustration by
Deanne Cheuk

"I'm such a Graphic Designer because I like to be told what to do."

FOCUS ON THE VISUAL EXPRESSION

Explore ways to develop the visual expression through form, color, and texture. Think about how to incorporate a softness in your work.

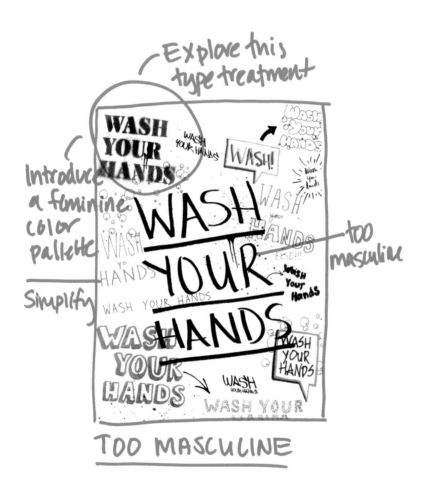

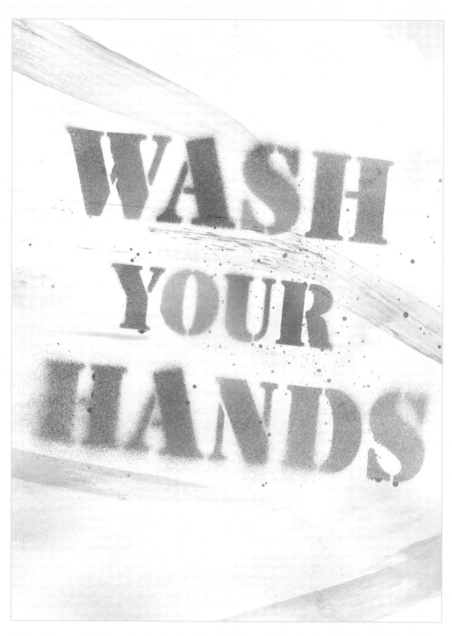

AFTER Deanne's feedback

MGMT

LOCATION	MGMT, Brooklyn, New York, NY
EDUCATION	BA, Oberlin College; MFA, Yale University
EMPLOYMENT	Co-Founder, MGMT, New York, NY
DURATION OF REDESIGN	2 days

"Think about making something smart and informative."

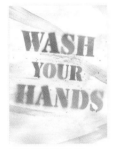

BEFORE MGMT's feedback

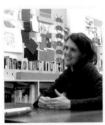

Sarah, responding to the poster

"I would suggest you start over," Sarah said.

I walked into MGMT's studio in Dumbo. Four designers sat with their backs toward me, working on computers. The studio was narrow and long. Alicia led me in. "I won't be able to meet with you today, but Sarah can," she said. I walked along a wall to the back of the studio, looking at all sorts of pinned-up images, sketches, and fabrics.

Sarah came over and pinned up my poster and we both sat down looking up at it. I explained my project and Sarah instantly responded. "OK, I'm not sure how I would suggest to further this," she said, tilting her head to the right, as if she were trying to straighten out the type.

Design duo Alicia Cheng and Sarah Gephart met in graduate school at Yale. After going their separate ways for a few years, they joined forces to start MGMT, a design firm that focuses on taking complex information and communicating it in a visually effective way. They're best known for their design work for Al Gore's *An Inconvenient Truth*, and illustrations for GOOD, *Metropolis*, and the *New York Times*.

Sarah didn't suggest ways to iterate the poster. Instead, she suggested starting over. "You have your work cut out for you," she said. Rather than seeing the feminine quality I was going for, she pointed out that the typography felt militaristic and the background looked like smeared lipstick.

"It needs to inform the viewer," she said. For her it didn't matter whether it was feminine or pretty. She suggested some kind of information graphic or story with information embedded in it. Her approach to a project like this would be starting out with interesting information and thinking about how to visualize it in a compelling way.

She started throwing out ideas, suggesting that I try to figure out how long you're supposed to wash your hands, and then design a poster with text that equals that amount of reading time. I thought it was a clever idea, but I wasn't sure how it was addressing the problem of actually getting people to wash their hands.

She talked through a few different ideas that could incorporate more information and humor.

"You could think about how you could make washing hands 'the thing to do,'" she explained, encouraging me to find the most compelling data I could and illustrate it.

She proposed a general direction of visualizing information, but didn't define any particular content or visual language. She described an information graphic that had lots of information embedded in it and could perhaps tell a story. "Think about making something smart and informative," she said.

When she talked about what the poster should be, I thought of all the information graphics the studio produces and wanted to use that as a reference.

I left the studio, and while still on my way back home, started sketching and researching all types of data related to hand washing. I wanted to blow out the idea of being informative and create a poster that was packed with interesting facts.

Design by MGMT

"It needs to inform the viewer."

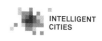

Design by MGMT

SARAH GEPHART OF MGMT ON INTELLIGENT DESIGN

Design by MGMT

Do you have a unique process or a particular way you approach design?
We approach all projects with substantive research and a conceptual rigor that is an integral part of our process. What we like most is taking complex information and translating it into visually effective and intelligent design solutions.

If you're stuck on a solution, what do you do?
I step back and take a break from it.

How often do you experiment?
I think we're experimenting all the time in our work.

How would you describe your voice in design?
We're smart, informative, and we often try to inject some element of humor.

What's the future of graphic design?
I can't really say what our future is.

Design by MGMT

COMPARING VOLCANOES

The April 14 eruption of Iceland's Eyjafjallajökull volcano disrupted air traffic over much of Europe and stranded thousands of passengers across the world. The total cost is estimated to be $5 billion in lost GDP through May 24, 2010. But now that dust has cleared, we can see that the eruption was small by historical standards, and there is always the chance of a bigger one. At any given time there are roughly 20 active volcanoes around the world, and there are 16 volcanoes—called "Decade Volcanoes"—that are currently noted to have a history of large eruptions and a proximity to populated areas. Imagine the cost if one of those erupts.

10 BIGGEST ERUPTIONS since 1000
(in cubic mile)

10 MOST DEADLY ERUPTIONS
(number of fatalities)

SOURCES: Steven Dutch, Natural and Applied Sciences, University of Wisconsin – Green Bay; Geoscicorp.com; Oxford Economics; United Nations Population Division; U.S. Geological Survey.
A collaboration between GOOD and MGMT design.

Design by MGMT

BE INFORMATIVE

Try to engage your audience by visualizing information in a compelling way. Explore ways to inject narrative and humor.

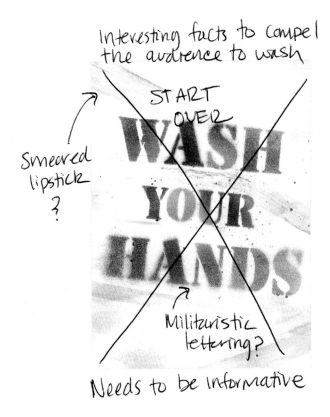

RUB WET SOAPY HANDS
TOGETHER OUTSIDE THE STREAM OF RUNNING WATER FOR AT LEAST **20 SECONDS**

WASHING YOUR HANDS
PREVENTS THE SPREAD OF THE FLU, COMMON COLD, AND DIARRHEA.

RESEARCH SUGGESTS PAPER TOWELS ARE MORE **HYGIENIC** THAN ELECTRIC **HAND** DRYERS.

UP TO

10
MILLION GERMS

LIVE ON **YOUR HANDS** AND THE **NUMBER DOUBLES** AFTER USING **THE TOILET**

RUB YOUR **HANDS** TOGETHER
MAKE A **LATHER**
AND
SCRUB THEM WELL.

BE SURE TO **SCRUB** THE BACKS OF YOUR **HANDS** BETWEEN YOUR **FINGERS** AND UNDER YOUR **N·A·I·L·S**

DRYING HANDS COMPLETELY IS ESSENTIAL IN THE **HAND WASHING PROCESS.** **WET HANDS** ARE MORE LIKELY THAN EVEN **DIRTY HANDS** TO CARRY GERMS.

DON'T GET CRAZY.

EXCESSIVE HAND WASHING IS COMMONLY SEEN AS A SYMPTOM OF **OBSESSIVE–COMPULSIVE** DISORDER.

MORE WOMEN WASH

75% OF WOMEN VS **58%** OF MEN

WASH YOUR HANDS

THE CLEANEST **HANDS**
IN THE U.S. ARE IN: CHICAGO AND SAN FRANCISCO

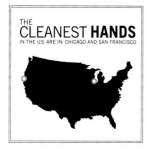

AFTER RECALLING OR CONTEMPLATING UNETHICAL ACTS, PEOPLE TEND

TO WASH THEIR HANDS
MORE OFTEN THAN OTHERS.

BE SURE TO USE **PAPER TOWEL** TO TURN OFF **THE FAUCET.**

!!

REMEMBER, YOU JUST TURNED ON THE FAUCET WITH YOUR **DIRTY HAND**

THOSE WHO ARE ALLOWED **TO WASH THEIR HANDS** AFTER SUCH A CONTEMPLATION, ARE LESS LIKELY TO ENGAGE IN OTHER "CLEANSING" COMPENSATORY ACTIONS, SUCH AS VOLUNTEERING.

MAKE SURE YOU **WASH FOR**

20
SECONDS

TRY SINGING THE **'HAPPY BIRTHDAY'** SONG TWICE

WHAT ARE YOU CARRYING ON YOUR

HANDS?

AFTER MGMT's feedback

STEVEN
HELLER

LOCATION	School of Visual Arts, New York, NY
EDUCATION	Self-taught
EMPLOYMENT	Co-chair of the MFA Designer as Author program at the School of Visual Arts New York, NY
DURATION OF REDESIGN	2 days

"If each one of these were a piece of a campaign, you've got an interesting campaign."

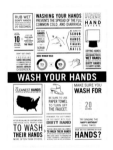

BEFORE Steven's feedback

Steven, responding to the poster

"Is it great design? No. It's functional design, and it's not ugly design, and individually it would be better design." Steven was practical and straightforward in his feedback.

We met at Steven's office at SVA. "Come in," he said as I stood at the doorway. His back was toward me as he continued to type an email. I sat down at the other desk in his office and started to set up my camera. Books overwhelmed the space, and a collection of miniature furniture was arranged neatly on a bookshelf. His office was cluttered with stuff.

Steven is the author, co-author, or editor of over 75 design books. He also generates all kinds of daily articles for various blogs, and he always seems to be working on his next book. Given the amount of work he produces, I imagine that every moment of his day is packed. The state of his office reflected his somewhat manic passion for all things design.

He rolled over to the other desk, "Shoot," he said, looking at me. I briefly described my project. He held up the poster and quickly tried to scan all of the information, "You have ten posters here," he said, putting the poster back down on the table. He immediately thought this was too much information.

He liked the idea of a poster to get people to wash their hands, but he questioned the effectiveness of PSA posters in general. "Who reads the choking poster? It's there because it's the law, but is it doing any good?" he asked. "Much too much stuff, more information than I need to know," Steven said.

He slowly scanned through the poster, reading one bit of information out loud and talking about things he liked and how they could work in a larger campaign.

Book by Steven Heller and Mirko Ilic

"That's pretty cool. Chicago and SF have the cleanest hands in the US," he said. He suggested slogans that could work as stickers. "It's a lovely thing, try singing happy birthday twice," he said. He pointed out typographic expediencies, where words were larger but didn't need to be emphasized, and suggested everything be the same weight, "right now your eye has to do a little too much work," he said.

"If each one of these were a piece of a campaign, you've got an interesting campaign," he said. He argued that public bathrooms are places where you don't want to linger and read a poster. You just want to wash and get out of there. He felt the poster would have more effect if separated into bits of information, like stickers or cards.

Book by Steven Heller

While a campaign was a really interesting idea, it didn't fit into the parameters of my project, so I asked, "What if it had to be just one poster?"

Instead of bouncing around ideas, he came back with a specific direction, "If it was one poster, I would just redesign it to have all of this information as a kind of contiguous read in the background. The main headline is 'Wash Your Hands.'" The direction he proposed literally brought the message to the forefront and gave the poster the clear hierarchy that he felt was lacking.

I had a clear direction of what the next iteration should look like: a continuous stream of supporting facts, with the main message on top. I mocked up a few versions and explored color and typography. The final poster was a super-simplified iteration of the previous poster. Even though the design was simplified, the same amount of information was communicated. But many of the problems Steven pointed out remained unresolved.

Book by Steven Heller and Lita Talarico

I appreciated that Steven's feedback immediately suggested how to broaden the scope of design to have more impact. And I observed that flyers, stickers, and other materials could become part of a larger campaign.

Considering that Steven is a designer who has spent most of his career working in traditional media, I was surprised and excited by his multi-faceted feedback. His enthusiasm and optimism about design seem to be endless.

STEVEN HELLER ON CALLING ON PEOPLE WHO ARE BETTER THAN YOU

Book by Steven Heller and Gail Anderson

Do you have a unique process or a particular way you approach design?

I don't design. I get an idea and then I act upon it. When I was a designer and when I was an art director, I'd have to solve it. My primary method was thinking about a metaphor/allegory or some sort of symbol that I could use, and I would work on that. I tried to find alternatives for the obvious. As an art director, more often than not, I would call on somebody to do it that was better than me. That's one method.

And today how do you start a project?

I get an idea. It comes from curiosity and interest, and there are certain triggers. I have a daily blog, so I have to come up with an idea every day. I have four or five media outlets that I have to feed on a regular basis, so I have to come up with ideas. I'm always looking, and it never fails that something will pop up. It could be very trivial or it could be very meaningful; but something will always pop up, and then I try to figure what the best way of handling it is. But I still call on people if I need something done that I can't do. I call on my students.

"My voice is of curiosity."

If you're stuck on a solution, what do you do?

Sometimes I just throw it away and don't deal with it. I don't get into situations today where I'm stuck. I have no problem doing something that's imperfect. I'll just do something and sometimes it will be totally irrelevant, but I'll make it relevant somehow.

How often do you experiment?

With writing, I try to get better. I try to change the way I write, but it's still within my vocabulary. It's hard to say, because I just think and sometimes the way I think is part of the formula. I'm usually affected by a stimulus. Visions don't just come from my brain like Thomas Edison or Leonardo—that's left for the visionaries. I just respond to things, and sometimes those

Book edited by Steven Heller

things are a bit weird. But I wouldn't say that I experiment too often.

How would you describe your voice in design?
My voice is of curiosity. It has question marks at the end of it, and every so often I'll have exclamation points.

What's the future of graphic design?
The future is something that I can't grapple with. I respond to things that look like they might be part of the future. I have a podcast up now on our website called "Nostalgia for the Future." I'm nostalgic for old futures.

I can only say that we're going to be working in many more media and we're going to be making more things either by hand or by machine, and "graphic design" (the terminology) may go away at some point.

I think designers will always have a large role, and graphic designers will find that just graphic design—you know, just doing your poster—is not enough, because this could be animated, this could be an app, this could be all sorts of things, and that's something that's within your power to do.

Book by Steven Heller and Gail Anderson

"I'm nostalgic for old futures."

Book by Steven Heller and Veronique Vienne

THINK BIGGER

Think about how a design can work in a larger campaign. Develop one piece of the campaign, but think about how it would translate to other formats and media. Create a variety of components that work together and separately.

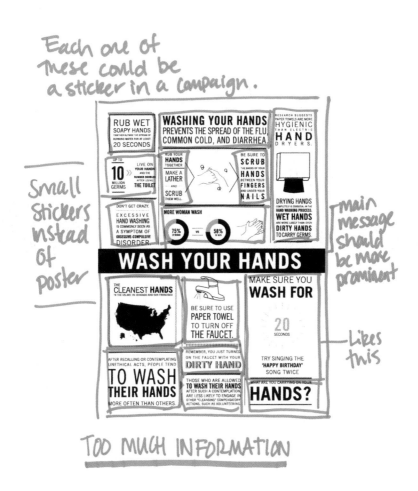

Each one of these could be a sticker in a campaign.

Small stickers instead of poster

main message should be more prominent

Likes this

TOO MUCH INFORMATION

WASHING YOUR HANDS PREVENTS THE SPREAD OF THE FLU, COMMON COLD, AND DIARRHEA. AS YOU TOUCH PEOPLE, SURFACES AND OBJECTS THROUGHOUT THE DAY, YOU ACCUMULATE GERMS ON YOUR HANDS. IN TURN, YOU CAN INFECT YOURSELF WITH THESE GERMS BY TOUCHING YOUR EYES, NOSE OR MOUTH. ALTHOUGH IT'S IMPOSSIBLE TO KEEP YOUR HANDS GERM-FREE, WASHING YOUR HANDS FREQUENTLY CAN HELP LIMIT THE TRANSFER OF BACTERIA, VIRUSES AND OTHER MICROBES. HAND WASHING, WHEN DONE CORRECTLY, IS ONE OF THE BEST WAYS TO PREVENT INFECTIONS, LIKE THE FLU OR COMMON COLD, AND LOWER YOUR RISK OF COPD EXACERBATION. MOST PEOPLE HAVE NO PROBLEM GRASPING THIS SIMPLE "TASK AT HAND," BUT MANY ARE UNAWARE THAT THE KEY TO WASHING YOUR HANDS PROPERLY TO WARD OFF POTENTIAL INFECTION IS ALL IN THE TECHNIQUE. THERE ARE A NUMBER OF SPECIFIC THINGS THAT FREQUENT AND PROPER HAND WASHING CAN HELP TO PREVENT. THERE IS NO CURE FOR THE COMMON COLD, PARTLY DUE TO THE FACT THAT THE STRAIN IS ALWAYS MUTATING AND CHANGING. WHEN INDIVIDUALS WASH THEIR HANDS MORE OFTEN, THEY ARE ABLE TO PREVENT THE SPREADING OF DISEASES AND GERMS. PEOPLE CAN GET THE GERMS THAT SPREAD THE COMMON COLD OFF OF THEIR HANDS BEFORE THEY PUT THEIR HANDS ON THEIR EYES OR MOUTH AND BECOME CONTAMINATED BY THE SICKNESS. BECAUSE IT

WASH YOUR HANDS

IS ALWAYS CHANGING, AN INDIVIDUAL WILL NOT DEVELOP ANTIBODIES AGAINST THE COMMON COLD, AND WILL ONLY BE ABLE TO STARVE IT OFF IF THEY HAVE A VERY GOOD IMMUNE SYSTEM, ONCE THEY BECOME INFECTED. HAND WASHING IS A SIMPLE TASK. MAKE SURE YOU USE SOAP TO WASH YOUR HANDS. THE CENTER FOR DISEASE CONTROL AND PREVENTION HAS STATED: "IT IS WELL–DOCUMENTED THAT ONE OF THE MOST IMPORTANT MEASURES FOR PREVENTING THE SPREAD OF PATHOGENS IS EFFECTIVE HAND WASHING." HAND WASHING PROTECTS BEST AGAINST DISEASES TRANSMITTED THROUGH FECAL-ORAL ROUTES, SUCH AS MANY FORMS OF STOMACH FLU. THIS HYGIENIC BEHAVIOR HAS BEEN SHOWN TO CUT THE NUMBER OF CHILD DEATHS FROM DIARRHEA , THE SECOND LEADING CAUSE OF CHILD DEATHS, BY ALMOST HALF AND FROM PNEUMONIA, THE LEADING CAUSE OF CHILD DEATHS, BY ONE–QUARTER. THERE ARE FIVE CRITICAL TIMES IN WASHING HANDS WITH SOAP AND/OR USING OF A HAND ANTISEPTIC RELATED TO FECAL–ORAL TRANSMISSION: AFTER USING A BATHROOM (PRIVATE OR PUBLIC), AFTER CHANGING A DIAPER, BEFORE FEEDING A CHILD, BEFORE EATING AND BEFORE PREPARING FOOD OR HANDLING RAW MEAT, FISH, OR POULTRY, OR ANY OTHER SITUATION LEADING TO POTENTIAL CONTAMINATION. TO REDUCE THE SPREAD OF GERMS, IT IS ALSO BETTER TO WASH THE HANDS BEFORE AND AFTER TENDING TO A SICK PERSON.

AFTER Steven Heller's feedback

MIEKE
GERRITZEN

LOCATION	Mieke's Home, Amsterdam, ND
EDUCATION	Gerrit Rietveld Academie, Amsterdam, ND
EMPLOYMENT	Director, Graphic Design Museum, Breda, ND
DURATION OF REDESIGN	2 days

"People can decide for themselves whether it's good or bad."

BEFORE Mieke's feedback

Mieke, responding to the poster

"I always like slogans that are a reflection, instead of an action," Mieke said.

I traveled to Amsterdam to meet with Mieke, intending to broaden the project by talking with designers in other countries and gaining new perspectives on design.

Mieke's work goes beyond traditional graphic design. Her current project, Next Nature, looks at the relationship between people, nature, and technology. She writes and curates work on the topic, and most of her work presents provocative ideas that shift your notion of nature.

I reached Mieke's home early in the morning. Schoolchildren lined up across the street in front of the school. She welcomed me and started making coffee as I explained my project.

"So the poster's goal is to get people to wash their hands," I said. "So you want me to wash my hands?" she asked as she turned on the water and poured soap onto her hands. I became concerned that a language barrier might prevent her from fully understanding my project.

Mieke brought over the coffee and sat down as I pulled out the latest iteration. "Oh it's about washing your hands!" she exclaimed, "I thought you wanted me to wash my hands." I quickly realized that the misunderstanding was just a miscommunication. Mieke's English was very good.

I didn't know what to expect from Mieke. Her work is so conceptual and deals with big issues such as media consumption. She looked over the poster, and her reaction was similar to Steven's: Too

much information to read. "It could be interesting to think about washing your hands in a philosophical way," she said. Most of her work plays with language and slogans, and it always has various underlying messages. For Mieke, this poster was too literal and practical. She proposed approaching the poster in a philosophical way, creating a poster about reflection instead of action.

"So is this designed for Africa or Baltimore?" she asked. Her questions were valid. Africa is obviously a place where handwashing is far more important and challenging than in the US, and it would require a totally different approach. She spoke slowly and was relaxed, sipping her cup of espresso and encouraging me to think about how the phrase could imply a double meaning.

"Usually people wash their hands after they've done something wrong, like commit a crime or lie," she said. She suggested making the viewer think about their moralistic values rather than taking action and washing their hands. She encouraged me to think about washing your hands in a philosophical way, "so it's not about getting sick or your health," she said. She advised making the poster current and perhaps using a logo of WikiLeaks next to the phrase "Wash your hands."

But where can this kind of nature be found nowadays? In the park on the outskirts of the town? Or on the windowsill, where your cat is gently sleeping? Probably not. Our next nature arises from cultural products that have become so complex that the only way we can relate to them is in terms of a man-nature relationship. There may even come a moment that our connection with an industrially manufactured coke bottle may be richer and more mythical that our relation with a genetically analysed and manipulated white rabbit in the woods.

Next Nature by Mieke Gerritzen

"People can decide for themselves whether it's good or bad," she said. She saw the poster as an opportunity for viewers to evaluate their own moralistic values about a current political topic.

I went back to my hotel in Amsterdam and started writing down idioms like "wiping the slate clean," "cleanse your conscience," and "wash away your sins." Since Mieke felt that the poster had too much information, I wanted to strip it down to a single slogan, leaving it open for the viewer to have his own interpretation.

"Usually people wash their hands after they've done something wrong."

I brought back the blue from a few iterations earlier and worked to keep it simple with just type. The phrase "Clear Your Mind" seemed to be the most open-ended and succinct. Instead of making the message specific by including a company logo, I chose to keep it nonspecific to embrace the philosophical tone.

Design by Mieke Gerritzen

MIEKE GERRITZEN ON MAKING REFLECTIVE WORK

Design by Mieke Gerritzen

"No sketching; I'm usually Googling."

Do you have a unique process or a particular way you approach design?
I have a process, but it's always different. It's not set.

Do you do a lot of writing or research or sketching?
I do a lot of writing, but not for my own work. I do a lot of writing and create a lot of books and stuff. But no sketching; I'm usually Googling. I haven't worked on any assignments for the last 10 years. So I'm doing my own things like creating a book or creating a scarf at the moment. Now I'm working on an exhibition in Milan where I'm creating a whole space with all kinds of wallpapers. But I just try out what kind of patterns will be best.

It's mostly a thinking process. If I know what kind of images I would like to use, then I just try to collect them and then put them next to each other in a certain system. And that's most of my process, to see what kind of repetition works.

If you're stuck on a solution, what do you do?
I just create or I'll stop for a while.

How often do you experiment?
I'm not making so much, and I'm working on one concept, so it's quite steady without much experimentation.

How would you describe your voice in design?
Well, I'm not so much a designer, because I just make things I like to do. So it's never very functional, except for myself.

The work I'm doing right now, like the silk scarves, is very decorated but also reflective.

What's the future of graphic design?
I think the designers of the future become software developers.

Designers who are just starting out should be learning code and writing code and creating software. And actually not creating so much imagery and styles for themselves, because most of the styles people try to find out now are just sort of remixes of old styles that were there before. Not so many people are really working on their own personal style.

So many people can do great design, not only professionals. I think graphic designers should learn to create software for people to create better stuff. Then the software directs you to a certain style, or to a certain way of designing.

Design by Mieke Gerritzen

GET PHILOSOPHICAL

Use language and image to allow the viewers to question themselves or the world around them. Think about how your work can serve as a moral compass for your audience.

Think about it philosophically

WASHING YOUR HANDS PREVENTS THE SPREAD OF THE FLU, COMMON COLD, AND DIARRHEA. AS YOU TOUCH PEOPLE, SURFACES AND OBJECTS THROUGHOUT THE DAY, YOU ACCUMULATE GERMS ON YOUR HANDS. IN TURN, YOU CAN INFECT YOURSELF WITH THESE GERMS BY TOUCHING YOUR EYES, NOSE OR MOUTH. ALTHOUGH IT'S IMPOSSIBLE TO KEEP YOUR HANDS GERM-FREE, WASHING YOUR HANDS FREQUENTLY CAN HELP LIMIT THE TRANSFER OF BACTERIA, VIRUSES AND OTHER MICROBES. HAND WASHING, WHEN DONE CORRECTLY, IS ONE OF THE BEST WAYS TO PREVENT INFECTIONS, LIKE THE FLU OR COMMON COLD, AND LOWER YOUR RISK OF COPD EXACERBATION. MOST PEOPLE HAVE NO PROBLEM GRASPING THIS SIMPLE "TASK AT HAND," BUT MANY ARE UNAWARE THAT THE KEY TO WASHING YOUR HANDS PROPERLY TO WARD OFF POTENTIAL INFECTION IS ALL IN THE TECHNIQUE. THERE ARE A NUMBER OF SPECIFIC THINGS THAT FREQUENT AND PROPER HAND WASHING CAN HELP TO PREVENT. THERE IS NO CURE FOR THE COMMON COLD, PARTLY DUE TO THE FACT THAT THE STRAIN IS ALWAYS MUTATING AND CHANGING. WHEN INDIVIDUALS WASH THEIR HANDS MORE OFTEN, THEY ARE ABLE TO PREVENT THE SPREADING OF DISEASES AND GERMS. PEOPLE CAN GET THE GERMS THAT SPREAD THE COMMON COLD OFF OF THEIR HANDS BEFORE THEY PUT THEIR HANDS ON THEIR EYES OR MOUTH AND BECOME CONTAMINATED BY THE SICKNESS. BECAUSE IT

WASH YOUR HANDS

Too literal

IS ALWAYS CHANGING, AN INDIVIDUAL WILL NOT DEVELOP ANTIBODIES AGAINST THE COMMON COLD, AND WILL ONLY BE ABLE TO STARVE IT OFF IF THEY HAVE A VERY GOOD IMMUNE SYSTEM. ONCE THEY BECOME INFECTED. HAND WASHING IS A SIMPLE TASK. MAKE SURE YOU USE SOAP TO WASH YOUR HANDS. THE CENTER FOR DISEASE CONTROL AND PREVENTION HAS STATED: "IT IS WELL—DOCUMENTED THAT ONE OF THE MOST IMPORTANT MEASURES FOR PREVENTING THE SPREAD OF PATHOGENS IS EFFECTIVE HAND WASHING." HAND WASHING PROTECTS BEST AGAINST DISEASES TRANSMITTED THROUGH FECAL-ORAL ROUTES, SUCH AS MANY FORMS OF STOMACH FLU. THIS HYGIENIC BEHAVIOR HAS BEEN SHOWN TO CUT THE NUMBER OF CHILD DEATHS FROM DIARRHEA , THE SECOND LEADING CAUSE OF CHILD DEATHS, BY ALMOST HALF AND FROM PNEUMONIA, THE LEADING CAUSE OF CHILD DEATHS, BY ONE—QUARTER. THERE ARE FIVE CRITICAL TIMES IN WASHING HANDS WITH SOAP AND/OR USING OF A HAND ANTISEPTIC RELATED TO FECAL—ORAL TRANSMISSION: AFTER USING A BATHROOM (PRIVATE OR PUBLIC), AFTER CHANGING A DIAPER, BEFORE FEEDING A CHILD, BEFORE EATING AND BEFORE PREPARING FOOD OR HANDLING RAW MEAT, FISH, OR POULTRY, OR ANY OTHER SITUATION LEADING TO POTENTIAL CONTAMINATION. TO REDUCE THE SPREAD OF GERMS, IT IS ALSO BETTER TO WASH THE HANDS BEFORE AND AFTER TENDING TO A SICK PERSON.

TOO MUCH INFORMATION

CLEAR YOUR HEAD

WASH YOUR HANDS

AFTER Mieke's feedback

VANESSA
VAN DAM

LOCATION Vanessa van Dam's Studio, Amsterdam, ND

EDUCATION Gerrit Rietveld Academie, Amsterdam, ND

EMPLOYMENT Vanessa van Dam Studio, Amsterdam, ND

DURATION OF REDESIGN 1 day

"You could do something special with the type."

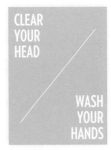

BEFORE Vanessa's feedback

Vanessa, responding to the poster

"I never heard of this double meaning," Vanessa said. I shared other phrases, like "wiping the slate clean" and "clearing your conscience." "Hmm, maybe it's an English thing," she said.

I was scheduled to meet Vanessa in her studio on a chilly December afternoon. I walked toward a colorful glass building at the end of a long pier in an industrial area of Amsterdam.

Vanessa welcomed me into her studio, leading me through a large open area to the other end of the space, where we sat down. It was quiet; there were only a few people present. Three colorful posters with big distorted type reading "IN FLUX" hung on the wall behind Vanessa.

Vanessa's work marks the cultural landscape of Amsterdam, as most of her clients are cultural institutions. She works with clients like the Royal Palace Amsterdam and the Dutch Architecture institute, among others.

We sat across from each other at a long table in the center of the room. She was tall and spoke with a strong Dutch accent.

As I set up my camera and described my project, Vanessa was eager to find out who I had met before her. I told her I would let her know as soon as we were done meeting.

I pulled out the latest iteration. "For this poster, I explored the philosophical meaning of washing your hands," I said.

"Tell me more about the double meaning," she said. I explained that studies show that people often wash their hands after they've committed a crime or lied about something.

"Oh, really? I don't know that saying," she said. She argued that this poster should be just for the United States, since she didn't quite understand the connection. I was confused. The saying can be found in sources such as Shakespeare and religious stories; and Mieke, a Dutch native, suggested this direction.

Since the language seemed to be tripping her up, I wanted to move away from the double meaning. So I asked what she thought about the visual aspects.

Her first response was that it felt empty. She suggested having some kind of image, not something obvious, but something that plays with the double meaning. She suggested finding an image that the viewer initially doesn't quite understand but became clear after thinking about it or seeing the poster a second time.

This feedback was incredibly vague. Specifically, she added that she would want to know why it was important for someone to wash their hands. On one hand she suggested a vague direction utilizing imagery, and on the other hand she was very specific about including content that educated the viewer.

She questioned the placement and location of the poster and talked through a variety of scenarios. She thought about this being presented in India. "I can imagine it could be a matter of being dead or alive," she said. "If it's for a kindergarten, then it wouldn't work," she said. I reminded her that the poster was for a broad audience and could be found in a public bathroom, such as in a train station.

"So it's for the general public?" Vanessa asked. I again explained the context that I was designing for. She moved on to suggesting a poster that presented what you shouldn't do, something like "Don't Wash Your Hands." "That could be interesting," she said. She had the feeling that she could decide for herself what to do or not do.

Vanessa bounced from idea to idea, many of them contradictory and unrelated. In general, she didn't understand the poster I was presenting and really didn't like the simplicity of it.

"You could do something special with the type," she said. She encouraged me to explore an image or do something more with the typography. She was general in her feedback, offering a range of disconnected ideas. She seemed to be openly talking through random ideas and jumping from one concept to another.

Design by Vanessa van Dam

Design by Vanessa van Dam

Design by Vanessa
van Dam

I had no idea what kind of image or what exploration of typography she was imagining. I felt lost in her feedback. I wanted to hear more about how she would approach the poster, so I asked her, "So if you were given this problem, say from a client, how would you approach it?"

"That's really hard to say. First I would start sketching and thinking and brainstorming," she said. I was hoping this would be part of our conversation. But after Vanessa responded, she just looked at me. It was quiet. "OK," I said after a few moments to break the silence.

Vanessa explained that she's not such a fast designer, and she's always needing to think and sketch and brainstorm. She'll try different things and see where that leads her. It was clear that Vanessa doesn't have a formulaic approach to her work, and she's not comfortable determining a fleshed-out idea on the fly. Rather, she likes to spend time letting her process lead her to a solution.

I didn't want to nudge the question any farther, so I moved onto the interview. The next poster had to be done in about five hours to allow time to get it to the printer and make my next early-morning meeting. I didn't have much of a direction, other than the suggestions to explore and question typography and think about introducing an image.

I had limited supplies with me, so I stuck to working digitally. I spent a few hours doing quick typographic sprints, playing with size, contrast, and layout. I continued with Mieke's concept of the double meaning and simply explored the layout and typography. After about 30 quick iterations, I settled on a simple layout, not that different from the original poster.

VANESSA VAN DAM ON THINKING AND DESIGNING

Do you have a unique process or a particular way you approach design?
The concept is always very important. I always start with thinking about what it is and who it is for. I start making rules, and it becomes more like playing with those rules in a way.

Do you do a lot of writing or research or sketching?
Yes. I research and I write, not seriously, just for myself. Research is also very important, of course.

Were you taught this process or is it something you developed over time?
I was taught this process at the Rietveld Academie, where I studied. You always had to explain why you did something. But it's also, of course, something that you learn by working.

How would you describe your voice in design?
I always try to put extra layers. I'm not just some hidden person who just does exactly what the client wants.

How often do you experiment?
All the time, I think. I experiment a lot, and of course, sometimes you come back to the place where you started; and of course, you also develop your own style.

But I think it's very important to keep experimenting, to refresh your ideas instead of thinking, "oh I'm good at this, I'll just continue doing this."

What's the future of graphic design?
Difficult question. I have no idea, to be honest. Everything will be more and more digitized. So we will be designing more for iPads and iPhones. But I think that printed stuff will always exist. That is a difficult question.

Design by Vanessa van Dam

"I always try to put extra layers."

EXPLORE TYPOGRAPHY

Explore and question the typographic solution. Spend time sketching and brainstorming and thinking about how your concept can be visualized.

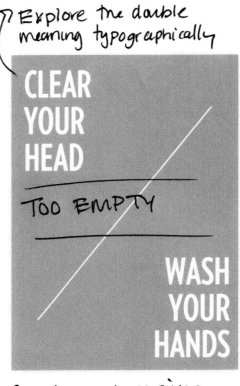

Explore the double meaning typographically

CLEAR YOUR HEAD

TOO EMPTY

WASH YOUR HANDS

The double meaning isn't clear

CLEAR
wash
YOUR
your
HEAD
hands

AFTER Vanessa's feedback

LUNA
MAURER

LOCATION	Luna's studio, Amsterdam, ND
EDUCATION	Gerrit Rietveld Academie, Amsterdam, ND
EMPLOYMENT	Co-founder, Moniker
DURATION OF REDESIGN	3 days

"I'm thinking of a process-based poster. I'm thinking about things that happen with water, with hands, what happens if there are many hands, from many people."

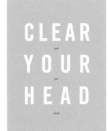

BEFORE Luna's feedback

"I would approach it in a completely different way. I would be interested in something which emerges over time and therefore tells its own story," Luna said. We sat next to each other looking up at the latest iteration pinned to the wall.

Luna designs systems and rules that invite viewers to participate. Her work brings design to a whole new level. The process is the product. Her interest lies beyond which typeface to use or how a color palette is chosen. For her, design is about what happens when she gives control to participants. I was excited to meet with her and curious about how she would respond to the poster and project.

I wandered the streets of Amsterdam looking for Luna's studio. The sun was setting as I searched up and down a block in a historic area. The streets were narrow and there didn't seem to be a logical system for numbering. A half hour later, a woman emerged from the building. "Luna?" I said. It was her.

I explained the trouble I had finding her while she led me up to her studio through an unmarked door and a series of stairways and doorways. "I would have never found this place," I said. The studio was in the attic of the building; the ceiling was low and the walls slanted inward with large beams of wood. She introduced me to her studio mates and announced, "She came all the way from America!"

Luna, responding to the poster

I explained the project as Luna pinned the poster to the wall. "This is a really bizarre message," she said. She wanted to know how

and why I came up with it. I explained that the poster wasn't really about the message. Rather, it serves as a vehicle to look at current approaches in design. Luna sat close, looking at me intently.

She gazed at the poster for a few moments with her hand on her chin and her eyes squinting. "This is something I would never do," she said. "To me, this is a boring slogan," Luna said.

She was interested in a solution that addressed bigger questions and perhaps even the paranoia of keeping clean. The idea of placing a poster in a bathroom with a bold statement, urging the viewer to do something, irritated her.

Design by Luna
Maurer / Moniker

"I'm thinking of a process-based poster. I'm thinking about things that happen with water, with hands, what happens if there are many hands from many people, what happens with liquid, and where there's a time element involved," she explained. She shared her thoughts freely, saying things as they entered her mind. She glanced at the poster, and down at her hands, and then back at the poster. Luna wanted to know what my stance was on hand washing. She wanted to hear my critical voice on the topic.

"How do you want to approach it?" she asked. I explained that I wanted to limit my personal take, and focus on her approach rather than my opinion. "Why?" she asked. "You have to put something from yourself in it."

"It's quite scientific; therefore, I would approach it scientifically."

I noted that when I design the poster, a level of interpretation and analysis takes place when I'm back at the studio. It wasn't that I didn't have a personal take on the design, but that the idea of the project was to incorporate the feedback I get into the work.

"So you don't exactly do what I say, but you're translating to what you want to hear," Luna said, looking at me with a straight face. "I hope I don't change it to what I want to hear!" I responded. "Well, I like the idea of the project, otherwise I wouldn't be talking with you," she concluded. I felt a sense of relief.

"So maybe it's about people putting their dirty hands on something," I said. We shared ideas, building off of each other. She proposed stating a question rather than a demand and providing a set of instructions for the viewer to act upon.

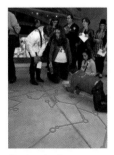

Design by Luna
Maurer / Moniker

She talked through ways to collect fingerprints, or even swallowing a pill that could somehow reveal the invisible bacteria on your skin. She let herself think of wild ideas without being limited to what was feasible or realistic for my project.

Design by Luna
Maurer / Moniker

Design by Luna
Maurer / Moniker

She liked the idea of somehow collecting hand prints in the city. We talked about ways to make bacteria visible, considering materials such as a transparent film, a mirror, or even a black light that would reveal hidden germs on the hands. Furthermore, we talked about developing a set of tools with which people could make their hands dirty.

But then she brought her thinking back to the project. "It's quite scientific; therefore, I would approach it scientifically," she said with certainty. She argued that I wasn't really trying to make a political or social statement but rather an analysis of the facts.

"What do you think?" she asked. She wanted to collaborate rather than instruct me on what to do next. I shared some ideas about how I could approach it scientifically, building off her initial prompt. "I could collect hand prints on a poster in a bathroom," I said. "That could be interesting to see where people make their prints, if they overlay each other or find a clean space," she said.

For Luna, it's not about just making a quick sketch or illustration. "To me, that's meaningless." She explained that her process for making a single poster is a big project. Sometimes she'll spend weeks building things that will result in a single poster.

I was ready to move away from the nuances of typography and slogans and explore a completely new and unique way of approaching design. I went back to my hotel room and started writing and thinking about different ways to collect fingerprints and reveal the invisible germs on hands, and create something that would emerge over time.

I immediately thought about petri dishes, collecting fingerprints, and watching the bacteria grow. I wanted to capture some kind of scientific data in the piece, so I thought about instructing users to write down when they last washed their hands. The hope was that less bacteria would grow if participants had just washed.

I would need at least a week to collect fingerprints and let the bacteria grow. Since my next meeting was the following day, I created a prototype that represented the idea but didn't show the full effect of the bacteria growing.

My conversation with Luna was less an art director instructing me on my next move and more of a collaborative conversation about how to make germs visible and invite the audience to participate. She jumpstarted my thinking, and by the time I sat down to write and sketch, I had a clear idea of how I could execute the poster.

LUNA MAURER ON EMBRACING YOUR AUDIENCE

Do you have a unique process or a particular way you approach design?
I start thinking. I develop a concept by letting myself be influenced by things I see, things that I think, things I read, contact with other people, things that inspire me. I never read design books.

Phenomena can inspire me a lot. It's all about the concept and the execution. If the design is good, it happens by itself.

When you're stuck on a solution, what do you do?
Think further. I never start on Monday and finish on Sunday. Even if I work only seven days on one project, they are spread over two months.

How often do you experiment?
Sometimes I know exactly what to do right away and it doesn't change at all. But other times, I start with an idea and the result is something very different.

How would you describe your voice in design?
I'm not looking for final products, but rather investigating and researching and letting things happen. I'm interested in incorporating and reflecting upon the environment in the process by setting out processes, making tools, and designing rules. I embrace the audience, their intelligence, and incorporate them.

We don't design finished pieces for a client. We give them a tool and then they can do it partly themselves. The client can engage with it and it's a bit from them. It also gets away from this perfect, clean design; and therefore, it gets more interesting.

What's the future of graphic design?
That term is old-fashioned. It's a problem of terminology because I think graphic design will always be related to designing a book or a poster, and I think that the media change is so much the future.

Design by Luna Maurer / Moniker

"I never read design books."

APPROACH YOUR WORK SCIENTIFICALLY

Think about how you can design a system with rules and tools that engage your audience and emerge over time.

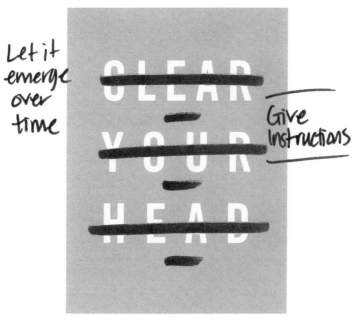

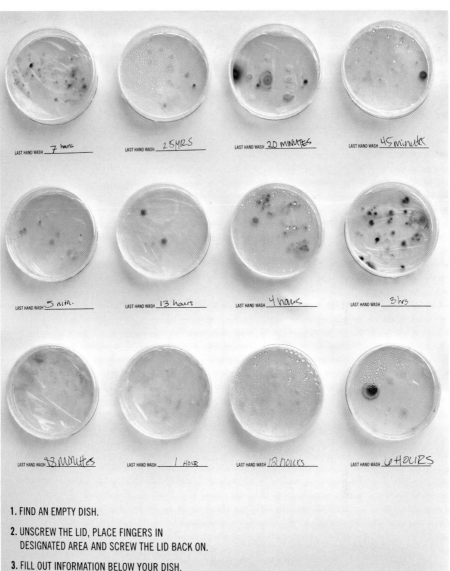

LAST HAND WASH _7 hours_

LAST HAND WASH _2.5 HRS_

LAST HAND WASH _20 MINUTES_

LAST HAND WASH _45 minutes_

LAST HAND WASH _5 min._

LAST HAND WASH _13 hours_

LAST HAND WASH _4 hours_

LAST HAND WASH _3 hrs_

LAST HAND WASH _18 minutes_

LAST HAND WASH _1 HOUR_

LAST HAND WASH _12 hours_

LAST HAND WASH _6 HOURS_

1. FIND AN EMPTY DISH.

2. UNSCREW THE LID, PLACE FINGERS IN
 DESIGNATED AREA AND SCREW THE LID BACK ON.

3. FILL OUT INFORMATION BELOW YOUR DISH.

4. COME BACK TO SEE YOUR DISH AS IT REVEALS
 WHAT'S INVISIBLE ON YOUR HANDS.

AFTER Luna's feedback

EXPERIMENTAL
JETSET

LOCATION	Experimental Jetset's Studio, Amsterdam, ND
EDUCATION	Gerrit Rietveld Academie, Amsterdam, ND
EMPLOYMENT	Experimental Jetset
DURATION OF REDESIGN	20 days

"Our approach would begin with asking, 'how can we express this in a typographic way?'"

BEFORE
Experimental
Jetset's feedback

Danny, responding
to the poster

"I think our approach would be totally different," Danny said. He was quick to respond.

An hour earlier, I had walked the streets of Amsterdam in a daze. I was so excited to meet everyone at the studio, but I didn't know what to expect. When I think of Experimental Jetset, I see vivid images of simplistic, bold typographic work that captures a spirit of idealism. Comprising three designers—Erwin, Marieke, and Danny—Experimental Jetset manages to amalgamate ideas into a singular consistent voice with great depth. While the work has a distinct style, I wasn't sure if the designers would urge me to design something similar or suggest an iteration of what I presented.

Danny welcomed me into their studio. Marieke and Erwin were working quietly on their computers. They had a deadline to meet, so only Danny could meet with me. The studio was one large room with a cluster of desks in the center, all facing each other. There was a quiet hum of music.

Danny and I sat down at a desk on the other side of the studio. I looked around as I set things up. Shelves of miniature foamcore models filled a wall, and a small kitchen was adjacent to us. The studio felt like a work in progress, ideas started and abandoned, models formed to visualize an idea quickly—collaborative thinking exposed by visual artifacts.

I described my project to Danny while he curiously looked at the poster. He instantly got it. "So it's a bland message that serves as a base over which you can measure all the different approaches," he replied.

I pulled out the prototype poster, and his response was similar. He could envision real Petri dishes with collected bacteria. "So this is a very process-based poster, that's collected over time," he said.

Danny liked the idea that the poster was stimulating a nervousness that some people have about bacteria and staying clean. It sparked his curiosity about a critique against cleanliness, and somehow getting people to be dirty to build up resistance to bacteria. This reflected the group's rebellious tendencies.

We flipped through an anarchist book that just happened to be on the table. Danny shared stories relating to images. We laughed about the absurdity of some, and then he put the book down and got back to the poster as if he didn't want to go too far down that path.

"If you would translate it to our approach, then it's quite simple," he said. "We would begin with asking, 'How can we express this in a typographic way?'" This response was exactly what I was looking for. Instead of meandering around what he liked and didn't like, he got straight to it.

He reached for a piece of paper and a pencil and started sketching. "We would start to look at how bacteria grows, and maybe it's in zeros," he said as he sketched lines of numbers getting longer and longer. He talked about how beautiful the typography could look, and how it could even work as an infographic. "In one glance, it gives you this idea of growth," he said. Danny's initial idea was simple and clear, capturing the essence of his studio's work. The group often focuses on how language, materials, and space can help shape its work.

"A good movie is always about movies, itself," Danny said, quoting a filmmaker. The studio relishes exploring how graphic design can reference itself. We discussed how the process of printing is actually making the poster dirty with ink, and how that could be an interesting relationship to explore. We wondered how we could show the poster getting dirty and then cleaned through the printing process.

"What if the paper itself looked like it was being washed? Or the bacteria was eating away at the typography?" Danny asked. As he talked through ideas, I had flashes of beautiful posters run through my mind. He was enthusiastic. He shared all his ideas as they came to him.

He stopped himself, and looking off into the studio, he said, "I think the numbers would be the best direction. It's easy—although

Sketch by Danny van den Dungen

"A good movie is about movies, itself."

Poster by Experimental Jetset

Poster by Experimental Jetset

Poster by
Experimental Jetset

"The scariest part is the moment that you get stuck."

I'm not propagating laziness, but sometimes it makes you think in a very efficient way."

Danny quickly understood my project and offered his approach. His feedback wasn't muddled with a bunch of ideas. It was clear and specific, just like the work he and his partners produce. In contrast to my project, they don't try to inhabit the mindset of their client or look to their client for a solution. They approach design in a way that comes from them, all their influences and ideas combined.

I left the studio with a sketch and a great feeling about design in general. The studio felt young and optimistic. Danny gave me two directions, but he clearly encouraged one over the other. I set out to use the sketch as a directive. I researched the statistics for bacteria growth on your hands over time and did lots of iterations, changing the type size and placement, adding more data, and stripping some out. I landed on a poster that I felt represented the ideas we talked about. It was simple, bold, and clear. The typography became the image.

Poster by
Experimental Jetset

EXPERIMENTAL JETSET ON THE DESIGN OBJECT AND BELIEVING IN YOUR OWN FUTURE

Do you have a unique process or a particular way you approach design?
The fact that there are three of us is quite important. Before we start a project, we talk a lot about the subject and give each other ideas. If the actual solution is sometimes small and minimal, you still think that all the information you absorbed is somehow captured in the image, even if you just create a big monochromatic piece of paper.

We usually start by digging into specifics, and every time you start a project you have to dig into another subject, and

suddenly you're an expert on this, and then an expert on that. So it's quite an interesting way to keep learning about stuff.

A lot of design studios are interested in the idea of the research, itself, becoming the work—which is good. But we are still traditional in that we think the end result needs some kind of aesthetic translation. We think it needs that extra step of turning it into a self-contained object, or poster, or whatever it turns into.

We make a lot of things by hand when we start out, like cutting and making models; and we do a lot of research. A lot of people don't see that. We're not romanticizing or fetishizing the research side, or the hand-work side, or the craft side. In the end, we do believe in the honesty of the design object, and we try not to put any romantic layers on top of that.

Signage by
Experimental Jetset

Were you taught this process or is it something you developed over time?
Many professors had an influence on us. We all went to the same academy. Erwin was two years below us. In general, there was a mentality of, "Just do it, don't talk about it, just do it." I think that still influences a lot.

The Rietveld Academie architecture also influenced us. The building makes you feel some kind of connection with the whole legacy of the 20th-century avant-garde.

All of us have been interested in, not graphic design, but creating stuff before we went to school. But at that time, graphic design was not something you could just do like you can now.

Signage by
Experimental Jetset

If you're stuck on a solution, what do you do?
The scariest part is the moment that you get stuck.

But I think the problem you always have is making a decision, because there's always all these different directions you can go. It's never that you have no solution, but that you don't know which solution to choose because there are so many. At a certain moment, you just push to choose one.

We are usually pushed a lot by deadlines, and at a certain moment you just have to choose something because it has to go to the printer. So we never have this idea of writer's block or designer's block. Circumstance usually pushes you to certain ways.

Poster by
Experimental Jetset

Design by
Experimental Jetset

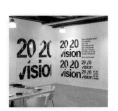

Design by
Experimental Jetset

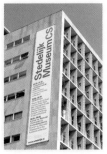

Signage by
Experimental Jetset

How often do you experiment?

I think the whole idea of experimentation, I mean, when you look at the whole—all our work together—you're constantly trying something, and then you try something else; and, of course, we're trying to refine something. So in that sense, in all of our work, we see some kind of experimentation because you're constantly correcting yourself. You're never happy with something you made. You always think, "Next time maybe we should use thinner paper, next time we should do this." So in that sense I think that a lot of our finished work is also the sketch for our next project.

It's experimental in the sense that it's not science. There's never a perfect solution, although you are looking for it. So you are experimenting without ever getting any results or any closure. There will never be a moment where you think, "This is the perfect solution for this context." We don't believe that there is such a thing as a perfect solution.

How would you describe your voice in design?

It's difficult, of course, because you can only truly say some-thing about something when you're outside of it. I think it's easier maybe for other people to say something about our studio. But how we see our voice has a lot to do with the idea that all three of us grew up in the Netherlands in the '70s, our teenage years.

The Netherlands was quite an interesting environment. There were these countercultural things going on, especially toward the end of the '70s. Then in the '80s we were influenced more by all the movements that came right after punk, and I think that what we try to do in our work is to synthesize these two influences. A lot of our thinking is very much influenced by this classic idea of a thesis and antithesis.

Our influences are pretty much formed by what you can refer to as post-punk culture. The kind of music we listened to when we were 14, 15, 16—new wave, ska—the first records we got in our hands made a huge impact on us. So we are always trying to synthesize those, too.

A lot of people say, "Well, you're doing some kind of pastiche thing." But it's not that you learn it from the books. It's not some kind of artificial style. It's really something we grew up into—and we feel shaped us so much—that we now have to

make it our own, and also load it with our own ideas and put our own influences in it.

Additionally, we also still feel very much connected to printed matter—maybe because we are the last pre-digital generation. We didn't grow up with computers.

What's the future of graphic design?
As a designer, you must have the idea that you can build a world around you, that you can design a T-shirt that suddenly everybody is wearing. The future is there, and even if three people still believe that there's a future for something, there is a future for that because you have it in your own hands.

Maybe it's better to talk about the *futures*. If only a couple people keep believing in something, then there will be a future for something. So of course you can speculate about how things will go, but it's way more interesting to realize that there are multiple futures.

That's a question that always sort of frightens us because it seems so deterministic, as if there's one future. In the end, the future is what you make it.

Poster by
Experimental Jetset

"As a designer, you must have the idea that you can build a world around you."

JUST TYPE

Restrict your font and your color palette and simply look at how typography can communicate your message.

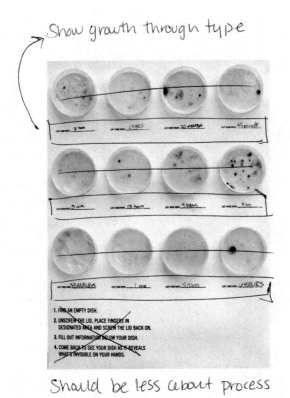

BACTERIA GROWS
QUICKLY ON YOUR
HANDS STARTING
WITH JUST 8 BACTERIA

bacteria	**8**
5 hours	**800**
9 hours	**80,000**
13 hours	**8,000,000**
17 hours	**800,000,000**
21 hours	**80,000,000,000**
24 hours	**8,000,000,000,000**
28 hours	**800,000,000,000,000**
32 hours	**80,000,000,000,000,000**

AFTER Experimental Jetset's feedback

PAULA
SCHER

LOCATION	Pentagram, New York, NY
EDUCATION	BFA, Tyler School of Art
EMPLOYMENT	Partner, Pentagram
DURATION OF REDESIGN	6 days

"Posters are for human beings, so they should be human."

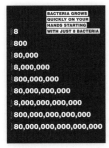

BEFORE Paula's feedback

Paula, responding to the poster

"Well, that's fine, that's one way to do it," Paula quickly responded after I explained the concept of showing bacteria growth typographically. She held up the poster for a few moments, scanning it and then setting it off to the side.

I was excited and nervous to meet Paula. She held up her new puppy in front of me, and she said, smiling, "This is Molly!" We met in Pentagram's New York office, where she's delivered smart and iconic work since 1991, as a partner in the firm. We sat down in the same office where I had met Michael Bierut a few weeks earlier.

For over four decades, Paula has been at the forefront of graphic design. She began her career as an art director in the '70s and became well known for her populist approach and unique typographic solutions.

In the mid '90s, she reimagined the identity for the Public Theater and continues to apply that identity to campaigns, signage, and posters. She's brought spirit and humanity to the urban landscape through her architectural collaborations, using graphic design to create a dynamic dimensional environment.

Paula held the poster in front of her again. "Well, what if I don't have any comments?" she remarked. I continued to explain the iterative nature of my project, and she asked, "So how many have you done so far?"

"20," I replied.

She laughed and joked that if I couldn't get it right by now, she wasn't sure she could help. "But the project sounds like fun!" she said. She had a lively spirit.

She finds that information graphics can educate but aren't action oriented. And that someone looking at the current poster would have no idea that it was about washing your hands.

"I would say just show a hand. Why don't you do one like that?" She offered a logical, human solution. She sympathized with my process of designing and redesigning this poster 20 times. For Paula, what's really disgusting is what's actually on your hands that you can't see.

"Have you done one like that?" she asked. "No," I responded. "Well, do you want to do one like that?" she asked nicely and laughed. I laughed along with her, nervously.

The language should be, "Wash Your Hands!" she said with her arms in the air. "Here, let me sketch it," she said, reaching for my notebook. "It could be a photograph or a diagram." She drew a hand with an inset full of bacteria. She encouraged me to make it look dirty and scary and to remember that the point of the poster is to get people to act. After sketching, she smiled and, looking down at the notebook, said, "Posters are for human beings, so they should be human."

She was quiet and sat back thinking for a few moments. "Washing your hands is a good way to not transmit diseases, especially to yourself. So 'wash your hands' is a really nice message, isn't it?" Paula said, shrugging her shoulders and laughing.

Molly jumped up on Paula's lap as she tried to calm her down. She grabbed her face, brought it close to hers, and said to Molly, "Wash your hands!"

Paula didn't overthink her feedback; she went with her instinct. She thought about what the average person would need to be encouraged to wash. Her laid-back attitude made design feel fun and conversational. Instead of telling me what to do, she asked if I wanted to do it.

I had a clear direction from Paula, and even a sketch. She was interested in revealing the germs on your hands that you normally can't see, using a scare tactic to get people to wash, and in general making a poster that was more human. Back at the studio, I started drawing and photographing hands. I quickly created many iterations with different drawn hands and photographs. Photographically, I explored different backgrounds and lighting. The photograph helped to make the poster feel more human.

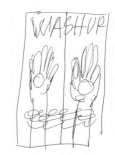

Sketch by Paula

"I would say just show a hand."

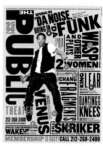

Poster by Paula Scher

Poster by Paula Scher

Poster by Paula Scher

I placed the photograph into a layout and played with simple language following Paula's directives, exploring imagery within the inset. I looked at some of my earlier bacteria paintings and drawings, along with microscopic photography.

I found that her specific feedback gave me constraints to design within but it didn't push me to explore. The concept was simple and straightforward. There are many ways to explore a human element in a poster, but her directions were very specific in her sketch.

"I think about people when I design."

PAULA SCHER ON DESIGNING FOR PEOPLE

Do you have a unique process or a particular way you approach design?
Just what we did, which is to try to figure out how people are going to use something, and how people perceive things. To put myself in, not so much a graphic design viewpoint, but to try to figure out where it is, what it is supposed to do, and how I can do that the most effective way that's understandable. Then, see if I can imbue it with some personality.

Identity by Paula Scher

Were you taught this process or is it something you developed over time?
It wasn't so much that I was taught it. It's that I understood, in time, that the most effective work was the work that people understood. The fact that they related to it or that they could connect to it. The work that I did for designers or for myself had a limited impact and people remembered it less. And I wanted my work to be seen and appreciated by lots of people, so I think about people when I design, and sometimes that helps me come up with a very straightforward way of communicating—which is important when you're doing identities, when people need to recognize something.

Identity by Paula Scher

If you're stuck on a solution, what do you do?

I think it's very bad to force myself, unless I'm just being lazy. I always try to go back and discern what the purpose is and what the goals are. And sometimes that helps and sometimes it doesn't. Sometimes I'm over-informed, which is a real stopping block. I'm much better if I work instinctively.

How often do you experiment?

Everything is an experiment. But sometimes I do what I know how to do because I'm out of time. So if I have to deliver a project and I've done a series of explorations and I haven't gotten any positive results, I'll pull back and do something tried and true. I really hate when that happens.

How would you describe your voice in design?

It's pretty loud. There are lots of things I'm known for and lots of things I'm not known for. But it's much more varied than people generally think. There's the big typography, there's the NYC Public Theater. I like doing large-scale typography integrated with buildings, and I have a passion for it because it's powerful. Then there's my identity work; that's much more systematic.

What's the future of graphic design?

That's a really, really good question. If you take the definition of design literally—which I do—design is planning, and anything can be planning. And I think the future of design is the ability for designers to use their vision to make things better. Whether it's to make things more entertaining, more socially relevant, more environmentally conscious, more *whatever* by virtue of their ability to do that. Designers always think they need strategists, but they are strategists, that's what design is.

Technology continually changes, but the thinking never changes. So that's the future of design. It will be adapting to different forms.

I'll tell you what I find really unnerving, and what has changed the most for me in 40 years, is the way that people communicate in groups. The studio has got a lot quieter. People will email each other instead of getting up to talk to them. Maybe that's the future, we turn into pods and our mouths eventually go away. It's less about technology and how things are made.

"Everything is an experiment."

Signage by Paula Scher

"Technology continually changes, but the thinking never changes."

Signage by Paula Scher

EXPLORE A HUMAN, ACTION-ORIENTED APPROACH

Incorporate a human element into your work, whether it's language, imagery, or typography. Consider how your work can connect with your audience.

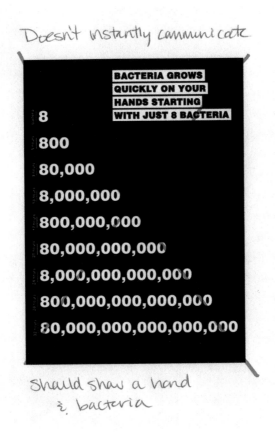

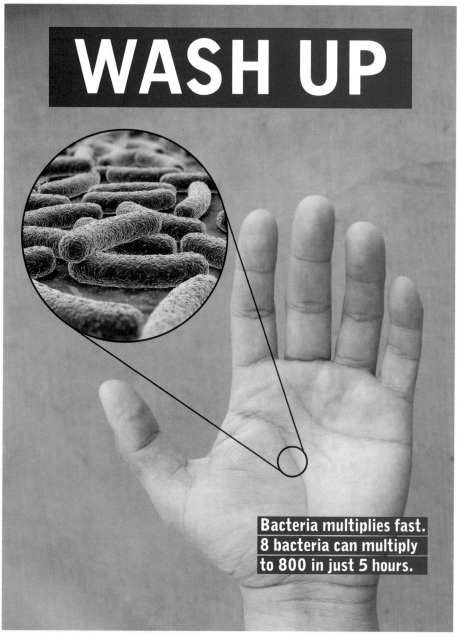

WASH UP

Bacteria multiplies fast.
8 bacteria can multiply
to 800 in just 5 hours.

AFTER Paula's feedback

KEETRA
DEAN DIXON

LOCATION	Maryland Institute College of Art, MD
EDUCATION	BFA, Minneapolis College of Art and Design; MFA, Cranbrook Academy of Art
EMPLOYMENT	Faculty, Maryland Institute College of Art, MD
DURATION OF REDESIGN	3 days

"Overwhelm the viewer with shocking, informative, and influential facts."

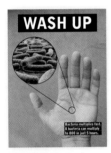

BEFORE Keetra's feedback

"Have you thought about stickers or mirror clings?"

Keetra, responding to the poster

"I actually think for this specific topic, I might not do a poster." Keetra quickly responded. "Have you thought about stickers or mirror clings?" she asked, standing above the poster. I instantly thought of Jennifer Morla and Stefan Sagmeister having the same response.

Keetra works in diverse mediums, often revealing her process in interesting ways. She leverages emergent technology, and exposes its failings, by hacking it or using the "mistakes" or artifacts of the process. Her work is playful and surprising and sometime invites the audience to participate.

We met at her office at the Maryland Institute College of Art. She was eager and enthusiastic about the project. "How many people have you talked to so far?" she asked. We sat at a desk, across from each other in her small office. She stood above the poster, trying to get a view from a distance.

She led the conversation by giving her initial feedback on the formal elements of the poster. The top typographic treatment made her think of bumper stickers, and the overall design reminded her of a mid- to late-'90s digital language. The attempt to shock wasn't enough. She observed that the weight of all the elements was optically about the same.

Keetra suggested that I add more information, and place facts on the areas in which you're actually encountering germs. She imagined stickers and mirror clings placed all over the bathroom, and the poster working as a culmination of the information.

"There are all these opportune places our eyes hit, like the toilet handle or the doorknob," she explained. She imagined sequential messaging throughout the bathroom experience. "Overwhelm the viewer with shocking, informative, and influential facts," she said.

Beyond the informational aspect, she suggested "a first-level read that could offer wisdom, like 'it's wise to wash up'" and then overwhelming the audience with facts. The idiom was less slogan-like and could function as a gentle welcome into the information. She felt strongly that the audience should make its own decisions after taking in the good and bad sides of hand washing. I started to imagine a poster diagramming the bathroom space, and hot spots representing bacteria count. Overall, she wanted more dynamism and more of the language of anatomical diagrams.

Keetra guided me to start with research, making sure that I could find interesting and surprising facts—information that would really compel the viewer. After that, she suggested looking at public awareness work, signage, instructional diagrams, infographics, isotopes, and anatomical renderings.

I loved the idea of empowering the audience to make their own choices by giving them interesting and relevant information.

Throughout our conversation, I had visions of what the poster could look like. I imagined an information graphic that captured the entire bathroom experience with germ counts and facts. I researched idioms and selected 'Cleanliness is next to Godliness.' It felt lighthearted and optimistic.

I went on to diagram the female and male bathroom experience with an overlay of facts and an idiom as a headline.

Poster by Keetra Dean Dixon and JK Keller

"There are all these opportune places our eyes hit."

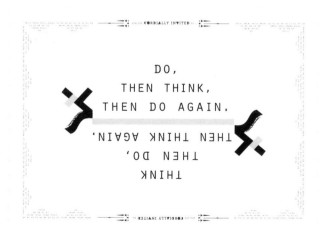

Poster by Keetra Dean Dixon

KEETRA DEAN DIXON ON PROCESS AND SURPRISE

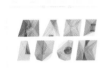

Poster by Keetra
Dean Dixon

*"I do an
immense
amount of
research."*

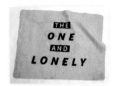

Poster by Keetra
Dean Dixon

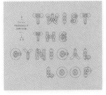

Poster by Keetra
Dean Dixon

Do you have a unique process or a particular way you approach design?
When someone poses a problem to me, I always have an instantaneous, "I know what I'll do!" So I write that down and put it away and try to inform myself.

I do an immense amount of research, and give myself a deadline no matter what—even if it's like three hours from now. I'll look online, go to people, books. So that's my research and discovery phase. From there, I start sketching, usually by hand, with a lot of visuals, but also lots and lots of list making. And depending on the type of project, it usually involves some sort of creative descriptor that summarizes the essence of what I'm trying to convey, which is a pretty typical part of the process. Then I'll move into the first round of design, and typically I pursue three ideas in one form or another; and for revisions, if I'm working with a client, I like to have three revision stages. I often do a lot of moodboarding in combination with material swatches and sketches, and placing the creative descriptors all in a visual context. Then I'll move into digital format, and getting more concise, and actually encapsulating potential output.

So how often do you go back to that first instinctual reaction?
Probably 50 to 70 percent of the time. You know, I always heard that the first idea, you shouldn't use and you should just get out of your system. But most of the time it's the one that's best received.

Were you taught this process or is it something you developed over time?
I was taught variations of the process in school, and I went to school for very traditional graphic design. And I really learned a solid foundation for those processes in my first internships. Since then I've integrated my own variances through practice, which often incorporates me waking up in the middle

of the night and making notes on my iPhone. And those get presented to the client. I think that's maybe something that's unique about me. I tend to be a little bit too transparent.

How often do you experiment?

As much as I can. Some people may call it synthetic, but I really do force myself to inhabit the head space of the wrong audience, or start making with some kind of process that doesn't fit the concept. So, actually inserting wrong methodologies to kind of trip myself up and surprise myself.

How would you describe your voice in design?

Spazzy, over-exuberant, overly optimistic, and playful and investigatory. If I just default and don't keep myself in check, I really fall in love with form and I can just meander off into oblivion. That's inherently what I do, but I really enjoy balancing that with a project that pursues a reflection of the client. My voice evolves every time I work with a client that I have no empathy for initially but then get to inhabit them.

What's the future of graphic design?

That's hard because I don't think graphic design has had a really clear definitive description. It's always changing in relation to technology and media and culture. I think we'll always be focused on facilitating communication, or communicating and looking at how that happens, and looking at how to successfully leverage current evolutions of technologies and culture. And that's the only consistency that there can be.

I would say in the future a graphic designer would have multiplicity of expertise in how to communicate through media vehicles, and I think that scale is a really huge definition for a graphic designer. I didn't consider it so much until I worked within architecture, and now I think of the architect having a bird's-eye view but they can only zoom in to a certain level, and then the graphic designer gets intimate. So I think of graphic design as human scale and smaller.

Swing Hall installation by Keetra Dean Dixon

"Inserting wrong methodologies to kind of trip myself up and surprise myself."

Poster by Keetra Dean Dixon

Poster by Keetra Dean Dixon

INFORM, INSPIRE, AND LET YOUR AUDIENCE FORM THEIR OWN OPINION

Overwhelm your audience with information that's interesting, informative, and surprising. Don't tell your audience what to think; let them decide for themselves.

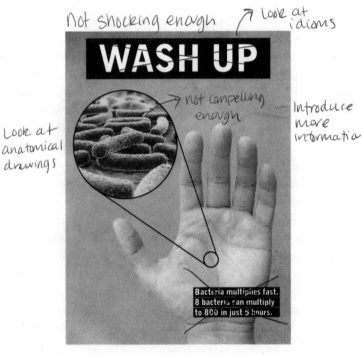

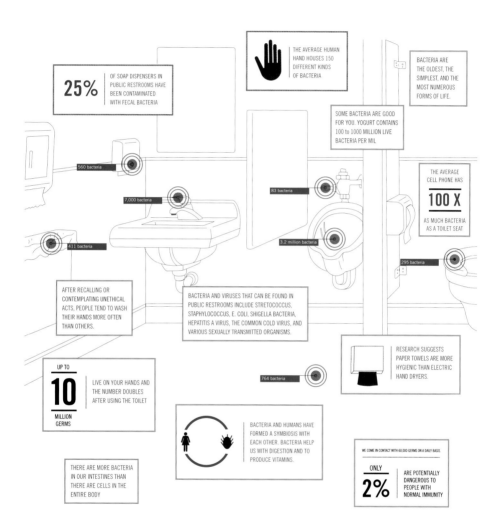

Cleanliness *is next to* Godliness

25% OF SOAP DISPENSERS IN PUBLIC RESTROOMS HAVE BEEN CONTAMINATED WITH FECAL BACTERIA

THE AVERAGE HUMAN HAND HOUSES 150 DIFFERENT KINDS OF BACTERIA

BACTERIA ARE THE OLDEST, THE SIMPLEST, AND THE MOST NUMEROUS FORMS OF LIFE.

SOME BACTERIA ARE GOOD FOR YOU. YOGURT CONTAINS 100 to 1000 MILLION LIVE BACTERIA PER MIL

THE AVERAGE CELL PHONE HAS **100 X** AS MUCH BACTERIA AS A TOILET SEAT

560 bacteria

7,000 bacteria

83 bacteria

3.2 million bacteria

411 bacteria

295 bacteria

AFTER RECALLING OR CONTEMPLATING UNETHICAL ACTS, PEOPLE TEND TO WASH THEIR HANDS MORE OFTEN THAN OTHERS.

BACTERIA AND VIRUSES THAT CAN BE FOUND IN PUBLIC RESTROOMS INCLUDE STRETOCOCCUS, STAPHYLOCOCCUS, E. COLI, SHIGELLA BACTERIA, HEPATITIS A VIRUS, THE COMMON COLD VIRUS, AND VARIOUS SEXUALLY TRANSMITTED ORGANISMS.

RESEARCH SUGGESTS PAPER TOWELS ARE MORE HYGIENIC THAN ELECTRIC HAND DRYERS.

UP TO **10** MILLION GERMS LIVE ON YOUR HANDS AND THE NUMBER DOUBLES AFTER USING THE TOILET

764 bacteria

BACTERIA AND HUMANS HAVE FORMED A SYMBIOSIS WITH EACH OTHER. BACTERIA HELP US WITH DIGESTION AND TO PRODUCE VITAMINS.

THERE ARE MORE BACTERIA IN OUR INTESTINES THAN THERE ARE CELLS IN THE ENTIRE BODY

WE COME IN CONTACT WITH 60,000 GERMS ON A DAILY BASIS.

ONLY **2%** ARE POTENTIALLY DANGEROUS TO PEOPLE WITH NORMAL IMMUNITY

AFTER Keetra's feedback

DEBBIE
MILLMAN

LOCATION	Sterling Brands, New York, NY
EDUCATION	BA, State University of New York at Albany
EMPLOYMENT	President, Sterling Brands; Chair, Masters Program in Branding, School of Visual Arts
DURATION OF REDESIGN	14 days

"My sense is something like this should be much more telegraphic and single minded."

BEFORE Debbie's feedback

"There's a lot of information to read."

Debbie, responding to the poster

"There's a lot of information to read," Debbie said. She was immediate and direct in her response. Keetra's directive was to overwhelm the viewer, so her reaction seemed appropriate.

Debbie welcomed me into her corner office at Sterling Brands on the top floor of the Empire State Building. I sat down across from her at a large wooden desk. A wall of books filled the area behind her. As president of Sterling Brands, she leads teams in developing branding for large companies like Pepsi, Gillette, Colgate, and Kimberly-Clark. But she's perhaps best known in the design world as the host of Design Matters—a podcast in which she interviews designers.

I was curious to see where she would guide me, as most of her work for global brands is directed toward a broad audience—similar to this poster.

"My sense is that something like this should be much more telegraphic and very single minded," she said. She encouraged me to use less language and consider how a single symbol could communicate the same message. She argued that not everyone can read, and especially in New York, not everyone speaks English.

"The more you are communicating in iconography or something universal, the more likely you are to engage with the viewer's imagination," she explained. She pulled out a piece of paper and started sketching. "You could use the No symbol," she said as she sketched, "and have any number of germs in it."

For Debbie, this was an opportunity to create something that could become the new industry standard. I got the sense that she thinks broadly and boldly about design. Her interest wasn't in creating a new poster that was beautiful or more thoughtful. Debbie was interested in changing behavior and having the most impact on a diverse audience.

She gave specific feedback to utilize iconography, cut down on language, and create a message that's easier to understand. She didn't encourage a new iteration of the poster I presented. Rather, she directed me toward a totally new design and approach.

Design by Debbie Millman, Sterling Brands

As we finished, she gave me a hug, and I left her office feeling enthusiastic and excited to distill my message and create something anyone could understand. I wanted to build off the simple sketch she created and think about how germs could be incorporated into the symbol.

Back at the studio, I sketched the No symbol made of germs. I liked the idea of little germs swarming around to create the No symbol and quickly moved to making that into a digital comp. I repurposed the existing hand-drawn bugs I created for earlier iterations. From there, I played with color and simplified the language.

Design by Debbie Millman, Sterling Brands

The result was a black poster with neon-green bugs forming the No symbol. I thought the color would contrast with a bathroom environment, and the neon bugs really stood out from the black. While the symbol communicated the message, the bug drawings helped draw the viewer in.

Debbie's feedback inspired me to explore. With the foundation of using a No symbol, I was tasked to create a super simple poster that would translate across languages and ages.

Design by Debbie Millman, Sterling Brands

DEBBIE MILLMAN ON CONSTANTLY EVOLVING HER APPROACH

Design by Debbie Millman, Sterling Brands

"I don't think that anything can be rigid in the way you approach things."

Do you have a unique process or a particular way you approach design?

No, I don't. It really depends on the project, actually. If I'm doing something in branding, then I tend to use a lot of pre-designed equity evaluation, consumer insight, marketplace analysis—reconnaissance of sorts. I can't tell you that with every single design project I undertake a very specific design process; but for different types of projects I might undertake specific processes that I know from experience will be beneficial to the journey.

For branding I start with a lot of research. Anytime you're working on a large brand, it would be reckless to not get a sense of what is happening in the market, how the brand is being perceived, and how change might be received. Despite people like Massimo Vignelli, who I adore, or others that don't believe in research, for me [not researching is] like a chef not caring if the patrons of his restaurant like the food. You want that branding feedback. You want to know how people respond to it, how they relate to it, what they see into it, what they experience; and I think that is really critically important for any design process.

If I'm doing illustration work, which I consider to also be design, it's a very different process. It's a completely different type of journey, and my process there is very insular and very self-reflective, and very much dependent on germination and time and connectivity.

Were you taught this process or is it something you developed over time?

Very much learned and helped create that process. There were certain aspects of the way that we work on brands that were already in place when I got to Sterling Brands 18 years ago. But there's been quite a lot of evolution of that

Design by Debbie Millman, Sterling Brands

process, so initially I learned about the tenets of branding and what's important to understand and know and feel and realize.

But over time, it's been very much a learned and created process. You know, you learn something about a marketplace and you learn and adjust. I don't think that anything can be rigid in the way you approach things, because every situation is different. Also, you are coming to that situation with a whole slew of learned behaviors and responses from the last time that you did something. So, there's a lot of pattern recognition and experience that fuels any new efforts.

Design by Debbie Millman, Sterling Brands

How often do you experiment?
Every day. I feel like my whole life is a whole series of experiments in success, failure, frustration and joy, self-loathing, self-confidence. It's a whole lodge of equations that sometimes work and sometimes don't. I just saw something today that Brian Collins posted on Facebook. It was a quote by Robert Frost: "The afternoon knows what the morning never suspected."

"I feel like my whole life is a whole series of experiments."

How would you describe your voice in design?
Optimistic, celebratory—I've been accused of fawning over my subjects in design matters, but I willingly accept that charge because I tend to only want to interview people that I admire and that I feel are doing things that deserve to be extolled.

What's the future of graphic design?
What we make it. I think that we'll likely see more technological advancement in far more work. I also think that we'll continue to go back to craft and artisanal design—you know, handmade.

Design by Debbie Millman, Sterling Brands

I think that the future of design will represent the future of our culture. Given that that's a big unknown, it's hard to predict—I'm more of an analyst than I am a futurist; but if I had to gauge what the future of graphic design is, I would say that it's fundamentally intertwined with the future of our culture and, ultimately, the future of our species.

"I think that the future of design will represent the future of our culture."

LIMIT LANGUAGE AND UTILIZE ICONOGRAPHY

Consider how your message can be distilled into a single mark, and how a diverse group of people would understand your message. Try to make your work as concise as possible.

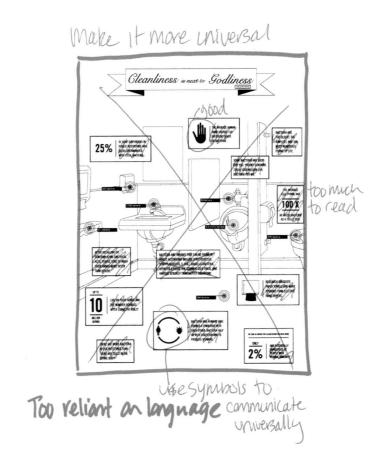

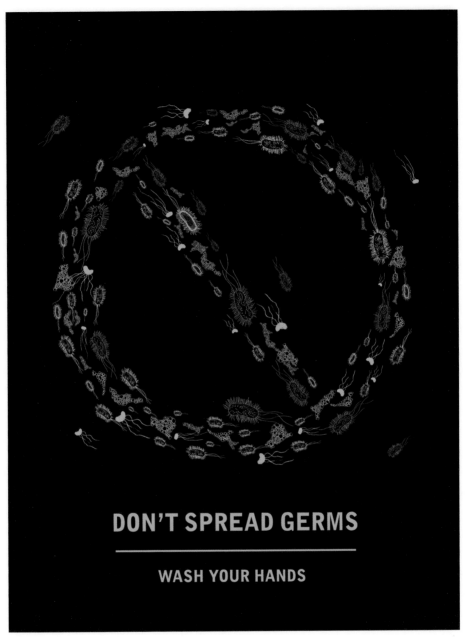

DON'T SPREAD GERMS

WASH YOUR HANDS

AFTER Debbie's feedback

ELLEN **LUPTON**
FINAL REDESIGN

LOCATION	Maryland Institute College of Art, Baltimore, MD
EDUCATION	BFA, Cooper Union; PhD Communication Design, University of Baltimore
EMPLOYMENT	Curator of Contemporary Design at Cooper-Hewitt National Design Museum, Director of the Graphic Design MFA program at Maryland Institute College of Art
DURATION OF REDESIGN	3 days

> *"If I saw this poster with a big black smudge and then moved closer to it and realized it was made of bacteria— that would be more of a surprise."*

DON'T SPREAD GERMS

WASH YOUR HANDS

BEFORE Ellen's feedback

"A smaller symbol that was teeming with life."

Ellen, responding to the poster

As my journey reached its end, I returned full circle by revisiting Ellen Lupton—presenting a poster that had been redesigned 23 times.

In her first round of feedback, she suggested I integrate language and image. The current version I was presenting was quite a departure—there were no hands, it was a black poster, and the language was minimal, with more reliance on iconography.

We met again in her office at the Maryland Institute College of Art. Since I didn't need to describe the details of the project again, I pulled out the new poster and Ellen quickly responded. She seemed excited to see where the poster had ended up.

I was curious what her reaction would be. The initial version had a large illustration with type on the bottom. In terms of layout, this poster was very similar.

"It feels grandiose," she explained, and noted that she still felt that the poster was too large for a bathroom. Then she imagined a further evolution of the poster.

"For me, if I saw this poster with a big black smudge, and then moved closer to it and realized it was made of bacteria—that would be more of a surprise," she explained, forming a circle with her hands to indicate the smudge. She wanted to increase the sense of dirt and contamination. This reminded me of Jessica Helfand's observation that the poster felt too digital. Lupton's feedback was

more about creating a beautiful poster than considering what would change behavior.

Additionally, she noted that the language was duplicative. For Ellen, the "NO GERMS" message wasn't necessary because that thought was implicit in the symbol.

Ellen was much more specific and instructive in our second meeting. She focused less on the bigger picture. Ellen proposed scaling down the symbol and creating a denser image of germs while removing unnecessary language. She envisioned "a smaller symbol that was teeming with life."

Illustration by Ellen Lupton

The meeting was quick. In contrast to our first meeting, she was direct and less ambiguous. She followed her gut reaction to the poster and made sure that I had a clear picture of what she imagined.

Since Ellen was so directive, I started the redesign by removing the color and creating a much denser area of bacteria, still forming the No symbol. This was a true iteration of the initial poster I presented.

As the final poster in my experiment, it marked the end of my journey. I was ready to step back, view the collection of posters, and redefine my own approach and create a new, final poster without any critique.

Illustration by Ellen Lupton

Illustration by Ellen Lupton

DESIGN FOR SURPRISE

Think about an image that will draw your viewer in and reveal a secondary image as your viewer moves closer. Partner iconography and language to surprise your viewer.

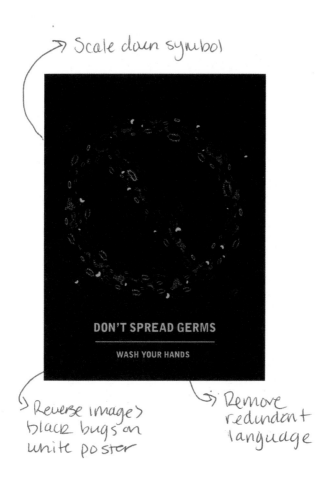

Scale down symbol

Reverse image> black bugs on white poster

Remove redundant language

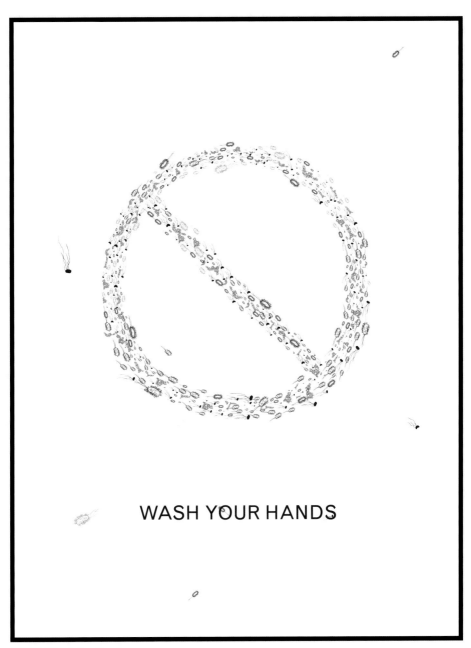

WASH YOUR HANDS

AFTER Ellen's feedback

FINAL POSTER
REDESIGN

DURATION OF 3 days
REDESIGN

"For me, this poster needed to be visceral, informative, and impactful for a broad audience."

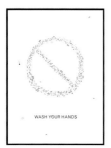

BEFORE My final redesign

"I would be able to reshape my own approach, influenced by this experience."

PROCESS Exploring form

This was the end of my journey. I had traveled to five cities and two countries and met with 23 designers, redesigning the same message 25 times. It was like running 25 sprints—back to back. I was in designer cross-training.

I came to a hard stop and was ready to step back and broadly look at all the iterations with a new perspective. Each poster was an experiment in inhabiting a different mindset. I learned new ways to approach my work—some methods worked for me, while others felt uncomfortable and contrary to my own voice.

In each conversation, I was amazed that every designer could clearly discuss how they approach work and their process. While some were vague, each one had a distinct point of view.

The final poster was an opportunity to present my redefined process after experiencing this journey. Ultimately, the experiment was 25 sketches that led me to this final poster.

For me, this poster needed to be visceral, informative, and impactful for a broad audience. And it was important for me to make something beautiful that would lure the viewer in.

I also wanted to utilize language to set the tone. When used effectively, language can convey a sense of empathy, playfulness, and urgency. I felt it essential to intertwine language and image and produce a poster that had two levels for the viewer to experience, from a distance and up close. And lastly, I wanted the poster to function as a piece of art while communicating an important message.

Initially, I started by looking at all of the poster iterations and writing down elements that I liked. I thought back about each design process and what I enjoyed most—like Jessica Helfand's improvisational approach and Rick Valicenti's focus on language

and beauty. I started writing down words that I felt described this new poster: visceral, informative, beautiful.

I sketched thumbnails of posters, thinking about language and image and how the two could work together.

I pushed the sketches to the side and moved on to exploring form—with no end result in mind.

PROCESS Exploring form

I pulled images I had already created. I photographed Petri dishes with growing bacteria, bubbles, and soap suds. I explored ways of distorting typography so that it felt dirty and gritty. I rubbed sandpaper over printed letters and poured water over inkjet prints. I hand-drew letters with pencil and ink and watercolor. I worked without having an end result in mind—just experimenting and improvising as I worked—building ideas on top of each other and throwing ideas to the side that didn't go anywhere. I followed my intuition.

PROCESS Exploring form

I played with the color palette and layering, and ultimately created a poster made up of Petri dish photographs, photographed bubbles, and sandpapered letterforms, along with an informative statistic. The language was friendly and short and not demanding.

At the beginning of this experiment, if someone had asked me to describe my design approach, I'm not sure I could have clearly and succinctly defined it. But at the end of the journey, I had a clear approach that I knew worked for me.

"I followed my intuition."

In this final redesign it was important for me to articulate and write down my own approach. I added notes as I was working and really tried to observe myself and document what were unique or important parts of my method. I found that I use writing to kick-start my process, and I typically don't have a clear image in my mind. I enjoy working through the process of improvising and experimenting, and as I work the image becomes clear to me.

PROCESS Exploring form

For me, the experiment was successful. I proved my hypothesis that after inhabiting all of these mindsets, I would be able to reshape my own approach, influenced by this experience.

The final poster presents a distillation of my journey and the evolution of my approach to design in general. Each conversation and iteration left me with a new way of thinking, and I would never have reached this final poster without having those 24 critical conversations about design with people who really changed the way I think and continue to influence the way I work.

PROCESS Exploring form

DESIGN FOR BEAUTY AND IMPACT

Create a balance between beauty and function, creating a poster that's informative and lures the viewer in through beauty. Explore and improvise without an end result in mind and follow your intuition.

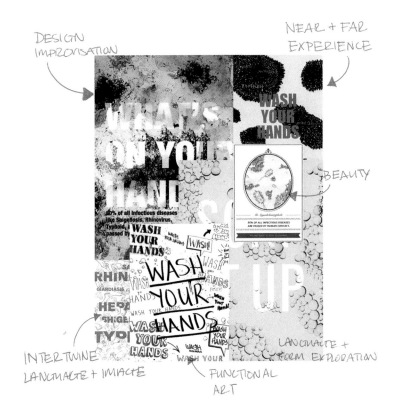

DESIGN IMPROVISATION

NEAR + FAR EXPERIENCE

BEAUTY

INTERTWINE LANGUAGE + IMAGE

FUNCTIONAL ART

LANGUAGE + FORM EXPLORATION

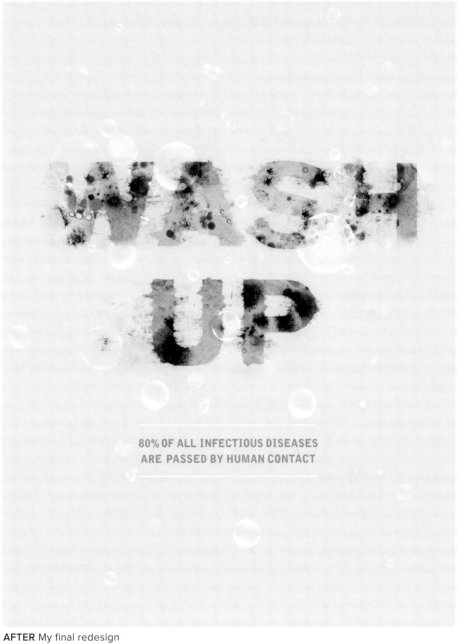

WASH UP

80% OF ALL INFECTIOUS DISEASES
ARE PASSED BY HUMAN CONTACT

AFTER My final redesign

THE EXPERIMENT

Below are 26 iterations of a single message, based on the feedback and approach of 23 leaders in the field.

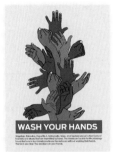

1 Initial Poster

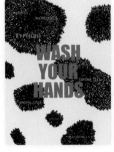

2 Ellen Lupton

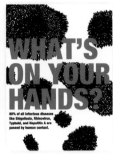

3 Paul Sahre

4 Alice Twemlow

5 Jessica Helfand

6 Maira Kalman

7 Axel Wieder

8 Micheal Bierut

9 Rick Valicenti

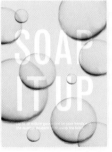

10 Jennifer Morla

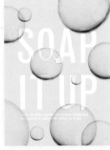

11 Michael Vanderbyl

12 Jason Munn

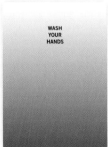

13 Stefan Sagmeister

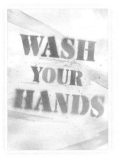

14 Rodrigo Corral

15 Deanne Cheuk

16 MGMT Sarah Gephart

17 Steven Heller

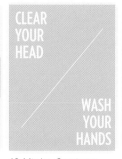 **18** Mieke Gerritzen

 19 Vanessa van Dam

 20 Luna Maurer

21 Experimental Jetset

 22 Paula Scher

 23 Keetra Dean Dixon

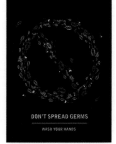 **24** Debbie Millman

 25 Ellen Lupton

FINAL POSTER

THE ANALYSIS

As this experiment proceeded, patterns emerged, ranging from how designers responded to the poster to how they described their design approach. This chapter examines those patterns in a subjective, nonscientific way.

Likes, Dislikes, and New Ideas

Each designer gave feedback in his or her own way. Some spent the conversation enumerating what they liked and disliked, while others focused mainly on new ideas.

■ 30 Likes
□ 42 Dislikes
■ 77 New ideas

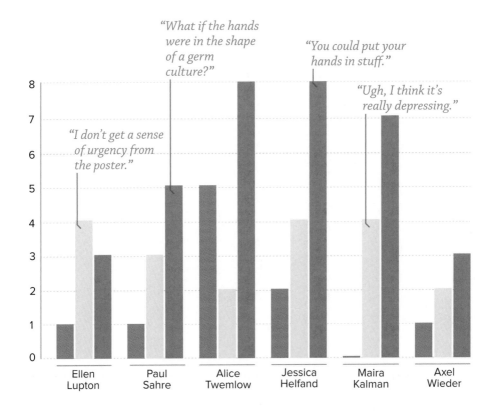

"I don't get a sense of urgency from the poster."

"What if the hands were in the shape of a germ culture?"

"You could put your hands in stuff."

"Ugh, I think it's really depressing."

Ellen Lupton · Paul Sahre · Alice Twemlow · Jessica Helfand · Maira Kalman · Axel Wieder

30
LIKES

42
DISLIKES

77
NEW IDEAS

The Design Process

Almost all designers favor an initial way of exploring solutions. Some head straight to research via the Internet, books, or people. Others have a conversation with a colleague or start writing lists. Whatever process they have, they've figured out what works for them.

"I do an immense amount of research and give myself a deadline no matter what."
— KEETRA DEAN DIXON

Research

Write

Talk

Sketch

"I spend a lot of time working it out in my head and I don't think by sketching, unfortunately."
— MICHEAL BIERUT

TOP THREE QUESTIONS THAT DESIGNERS ASKED ME

1. Who did you talk to before me?
2. How many posters have you made?
3. Does it have to be a poster?

5
participants
thought the message
shouldn't be in the
form of a poster

12
responded
verbally

THINK
was the word most
used by participants

Schools of Thought

During my experiment, I identified nine schools
of thought that clearly shapes the way each
designer approaches the work. Some designers
utilized a varied approach, while others stuck
to a specific tenet.

Aesthetic focus

User Centered

Simplify for universality

Ellen
Lupton

Paul
Sahre

Alice
Twemlow

Jessica
Helfand

Jennifer
Morla

Michael
Vanderbyl

Jason
Munn

Stefan
Sagmeister

Mieke
Gerritzen

Vanessa
van Dam

Luna
Maurer

Experimental
Jetset

7	4	6
started sketching	pinned up the poster and viewed it from a distance	rolled up the poster and pushed it to the side

Information driven

Expanding traditional graphic design

International typographic style

Language centric

Participatory

Functional art

Maira
Kalman

Axel
Wieder

Michael
Bierut

Rick
Valicenti

Rodrigo
Corral

Deanne
Cheuk

Sarah
Gephart

Steven
Heller

Paula
Scher

Keetra
Dean Dixon

Debbie
Millman

Christina
Beard

DESIGN CAN CHANGE BEHAVIOR: A WORKSHOP

David Barringer

A work of graphic design can inspire people to change their behavior. People are usually in a hurry and on their way to somewhere else. They are *here*, but they are on their way *there*. They are in this restroom, but they are on their way to the office, the airplane, or the theater. A work of graphic design, like a poster, can stop that person in their tracks and invite them to take a closer look.

That response alone has changed behavior: The poster has *made them look*. But that work of graphic design has a message, and the message is about making that person do something else: ride a bike to work, see a play this Saturday, or wash their hands right that second.

Changing people's behavior is difficult. If changing our behavior were easy, we would all be healthy, happy, wealthy, and wise. But we are, for the most part, not. We are not always kind to others or to ourselves. We are not always responsible. We are not always smart about diet and exercise. We make bad choices. We make lazy choices. We hustle out of the restroom, bypassing the sinks, convincing ourselves that we are in a hurry (and that no one is looking). We are good at knowing what we *should* be doing and still not doing it. We are human.

I was one of Christina Beard's advisers at MICA (Maryland Institute College of Art). I taught a spring course on writing thesis essays and helped her with the essay that was the seed of this book. The next year, while I was teaching undergraduate design and illustration majors at Winthrop University, I recalled Christina's poster project, and I decided her work would be a great catalyst for a workshop that explored how graphic design might change people's behavior.

THE WORKSHOP

I start each workshop by showing Christina's series of hand-washing posters. I try not to say a word. We just look at them slowly, one by one. We often look through the series two or three times. I might add some context or an explanation, but I don't make any judgments. I want the students to see how many ways designers can make posters that are supposed to change someone's behavior.

There is one goal—to get people to wash their hands—but there are many ways to try to do this. I want the students to stay loose, try anything, and *keep* trying anything. The variety of the posters—in style, media, and strategy—inspires willingness in the students to sketch freely.

The workshop has six stages (see "The Stages") that can last two to three hours in total. To encourage spontaneous creative thought, I do not share an overview of the six stages with students. I don't want them to know what's going to happen.

I hand out blank sheets of sketch paper, and we move one step at a time. The first four stages are prompts presented one at a time. Each is intended to help the student focus her creative direction. When students finish sketching ideas for one prompt, I reveal the next prompt, and they work on that one. I do not openly discuss their ideas until the fifth stage.

It's important for the students that the process works this way. I want them to focus on exploring one prompt at a time without the pressure of showing their work to anyone else.

The workshop is not about generating concepts that we will finalize later. On the contrary, the workshop is about thinking quickly, sketching quickly, and moving on quickly. Students have an easier time moving beyond their early drafts when their sketches remain private. I do not ask them to defend their ideas to the class. That would invite the students to commit to their work; and I am, in each stage, instead asking them to abandon what they have just done and move on to a new way of thinking.

I do not use the term *problem* in the workshop. Instead, I use the term *expression*. We are not "solving a problem." We are "generating expressions." Solving a problem implies that once we have "solved that problem," we can stop working (whether or not we

have empirically done anything other than made a poster). We can always generate more expressions, however, and in this way, we can always keep thinking and working.

So we express our ideas in words and images that can be put on a poster. The students come up with a lot of ideas, sketch out many concepts, and generate a bunch of different expressions inspired by whatever prompt I give them in the workshop. And that's what I'm after: lots of expressions, lots of sketches, and visual evidence of lots of good, hard thinking. And that's an achievable goal within a three-hour workshop.

THE STAGES

The following six stages outline the structure of the workshop:

1. Make It Clear.
Tell people exactly what you want them to do.

2. Make It Positively Primal.
Inspire a positive emotion in the viewer.

3. Make It Transformative.
Show how adopting the new behavior transforms you into a better person.

4. Make It Easy.
Redesign some or all of the restroom environment so that it's easy for a person to wash their hands.

5. Pick Your Best, Share with the Rest.
Pick out the best message in your own work, or quickly come up with something new, and then share with the class.

6. Identify What Sticks.
Write down the most memorable expressions other students have created.

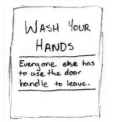

Sketch by Maura Anthony

STAGE ONE: MAKE IT CLEAR

After we look at Christina's series of posters, the students spend 10 to 15 minutes sketching quietly. They sketch thumbnail posters that contain one slogan and one image. The posters must have words and pictures working together. The slogan must tell people

what action to take. Imagine a viewer asking, "What do you want me to do?" The slogan must tell them: "Wash Your Hands," "Use Soap," "Wait until the Water is Hot."

In the 2010 book *Switch: How to Change Things When Change Is Hard* (Crown Business), written by Chip and Dan Heath, they cite case studies in which slogans are most effective when they "script the action." That is, the slogans tell people what action to take. Students are prompted to do that in this stage. The poster slogan should state, flat out, what people are supposed to do.

The image must reinforce that action. Imagine a viewer asking, "OK, I need to wash my hands. But how do I do that, exactly?" The image should dramatize the answer, literally or figuratively.

Rhiannon Bode came up with the following slogans: "Get Clean," "Suds Up," "Don't Let the Germs Get You Down," and "Feel the Clean." Samantha Cabrera wrote, "Use Soap to Prevent Disease," with an illustration of a bar of soap wearing a hero's cape and blasting germs with eye lasers.

Sketch by Amanda Moore

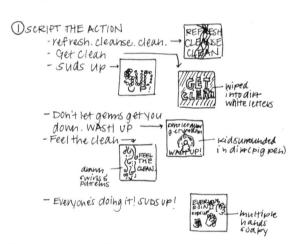

Sketch by Rhiannon Bode

STAGE TWO: MAKE IT POSITIVELY PRIMAL

Without discussing anyone's sketches, we move on to the next stage. I again show Christina's series of posters. I ask if anyone notices any trends.

Typically, students point out the many appearances of germs in the posters, as well as the statistics on disease. These are scare tactics, which is one strategy for changing behavior. The strategy

Sketch by Laura
Ketcham

is to show to people what happens when they *don't* change their behavior. If they don't wash their hands, they will remain dirty human beings, spreading filth and disease.

The challenge when using scare tactics is that the images repulse people. People don't stop and linger and look. Instead, they cringe and move on, quickly. The risk is that scare tactics do their job *too* well. They scare people away from the poster, and by extension, away from the opportunity to change their behavior.

And here's a great benefit to relying on Christina's posters: I find that I can safely critique these posters while maintaining the students' confidence in their own work. If I were to discuss the problem of scare tactics by critiquing a student's use of germs or dirty hands in her poster, I would run the risk of stifling that student's creativity for the rest of the workshop.

Keep in mind that I'm trying to inspire students to think quickly in many different ways in one three-hour workshop. So there's no time to wait for a student's cloud of bad feelings to drift away. That's why I don't critique student work openly during this work-shop. We are free, however, to critique the posters in Christina's series and remain positive and open in each stage.

Sketch by Maura
Anthony

I use Christina's posters as a springboard to talk about scare tactics versus positive messages. The emotions of fear and disgust push the viewer away. I ask the students to try to evoke other emotions that open up and pull the viewer toward the mes-sage. We want viewers to feel desire, not fear. We don't want to show the desert. We want to show the oasis. Don't tell people they're bad. Tell them they can be good. An image that evokes positive feelings will more likely draw the viewer into stopping and lingering and looking, and that makes it possible to inspire her to change her behavior.

Sometimes I explain this stage well, and sometimes I don't. I used to call this stage "Make It Primal," and I focused on primal emotions and forgot to emphasize the positive.

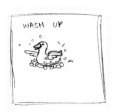

Sketch by Samantha
Cabrera

Not surprisingly, students thought of some pretty cool but still negatively primal images. One student drew a sick boy with a thermometer in his mouth for one poster, and for another she drew a germ that was "small but deadly." Another student drew hands dripping in blood, which might reference anyone from Macbeth to Dexter.

So I renamed this stage "Make It *Positively* Primal." That helped, but this kind of positive thinking remains tricky for young designers

(*any* designers, really) to accept and employ. The difficulty might arise because students might associate the use of positive emotions with advertising, and the use of negative emotions with art. I'm not sure of the actual reason, but I do find that I need to remind students that we have only one goal: to use design to inspire people to wash their hands. Because that's our goal, we must explore a variety of strategies, including the use of images that evoke positive emotions in our viewers.

Mario Balaguer used a funny pop-culture reference: "Getting sick? Ain't nobody got time for that." Mark Breeland also used humor: he drew a man wearing lederhosen, with the slogan "Wash Your Hans."

Maura Anthony drew a big mustache: "Wash Your Hands...So You Can Twirl Your Mustache." Rachel Sullivan drew a rubber ducky: "Squeaky Clean." Rhiannon Bode drew lovers holding hands: "Make the First Touch Unforgettable."

STAGE THREE: MAKE IT TRANSFORMATIVE

When I want someone to change his behavior, I am, in some sense, asking him to become someone new. That someone is, right now, the kind of person who does not wash his hands. In the poster, I want to show him that he can become someone better by becoming someone who *does* wash his hands. I want to inspire them to *transform* themselves, and to do that, I can show them the kind of person they can become with a change in behavior.

To show the students what I mean, I refer to one website and one magazine that demonstrate the transformation strategy in action: BeachBody.com and *O, The Oprah Magazine*. These are great sources for before-and-after images.

Look at the photographs on BeachBody.com, and you'll see that the people who buy and complete the exercise program transform from a flabby "before" to a fit "after."

Photographs in *O* show people transforming from an unfashionable "before" to a fashionable "after" (by losing weight and/or changing their wardrobes). Most of us tend to respond to these before/after images in a primal way because they promise a positive transformation that an average person can replicate. These messages pull us into a world in which changing our behavior means we become better people. And we want that.

Sketches by Rhiannon Bode

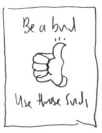

Sketch by Laura Ketcham

This is a tough stage. I ask the students to imagine transforming themselves from one type of person to another. They need to make this poster's message about transformation. Using graphic design to change someone's behavior, in this strategy, depends on dramatizing a vision of a new you. Students need time to imagine this, and so this stage typically takes longer than the previous stages.

After the students are done sketching, I discuss my own concepts. For example, I imagine a parent cradling a baby, an Average Joe shaking a famous athlete's hand, and a superhero gripping the hand of someone dangling from a building's roof.

Students have hit on the superhero concept, as well as the romantic motif (clean hands make you a better lover, and so forth). Mario Balaguer envisioned Moses with a new commandment: "Wash Thy Hands." He drew Moses with outstretched arms, palms up to receive the cascading waters of cleanliness.

RUB & RINSE ZONE

+Areas in public places to wash

Sketch by Amanda Moore

STAGE FOUR: MAKE IT EASY

In this stage, I ask students to think beyond the poster. In this stage, we are interested in the outcome. We want people to wash their hands. We don't care how they do it. We just want them to do it. So we are no longer sketching thumbnails of posters with images and slogans. We are imagining the little worlds of the public restroom, including those found in the school, restaurant, office, and airport. I ask the students to imagine the dynamic of people in a particular circumstance, and then to redesign that circumstance to make it easy for people to wash their hands.

This stage also takes a little longer than some others because students need time to recreate these scenarios in their minds and then consider how they might redesign restrooms—walls, stalls, sinks, signs, and soaps—to get hands washed.

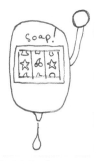

Soap!

Sketch by Jason Gotlieb

I first ask them to consider why people *don't* wash their hands. Imagine the person in the airport restroom. He hustles out of the room as fast as possible. By definition, this guy is not going to stand still and read a litany of statistics on a poster above the sink, because he doesn't even look at the sink. So how do we redesign the circumstance to change this result? Students have to imagine changing the dynamic, changing the circumstance—*designing* the environment to achieve this goal.

Students have imagined forcing people through a narrow hallway of sinks; building a hand-sanitizer into a smartphone case; installing hand-washing areas outside restrooms; providing liquid soap that changes colors the longer that children wash their hands; installing sanitizing spray on the exit-door handle; designing sinks to look like elephants to appeal to children; and publicizing to a social media network a name list of all those who leave with unwashed hands.

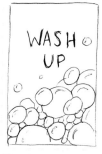

Sketch by Amanda Moore

STAGE FIVE: PICK YOUR BEST, SHARE WITH THE REST

I refer students to Atul Gawande's chapter on hand washing in hospitals in his 2008 book *Better*. He writes that about 90,000 people a year die from hospital infections. Even when 70 percent of the hospital staff washes regularly, the other 30 percent still spread germs. If someone could successfully design something to address this (a new poster, a new hand-san pump, a totally new circumstance), that person could save thousands of lives.

Sketch by Mark Breeland

Getting people to wash their hands is a seriously complicated endeavor. Students may assume hand washing to be an easy behavior to encourage, but it turns out to be a tough nut no one has cracked. Students spend 10 minutes reviewing all of their sketches. They pick out their own best message or quickly come up with something new, which they share with the class.

STAGE SIX: IDENTIFY WHAT STICKS

Only after everyone has shared their own favorite expressions do I ask them to write down the expressions they can recall. This is one way to see which messages have the potential to stick in people's minds. Everyone shares their memorable messages. We discuss possible reasons for why these remained in our memories.

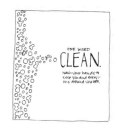

Sketch by Rhiannon Bode

Designers can inspire others to change their behaviors and, at least for a time, to be kind, eat healthier foods, or wash their hands. At the very least, you want people to pay attention to your work, to stop and look at what you've made. You can use this workshop to introduce design students to strategies for using design to change behavior. Make your message clear, primal, and transformative, and make it easy for people to change.

INDEX

future of
 Alice Twemlow on, 17
 Axel Wieder on, 35
 Deanne Cheuk on, 87
 Debbie Millman on, 143
 Ellen Lupton on, 4–5
 Experimental Jetset on, 125
 Jason Munn on, 69
 Jennifer Morla on, 53
 Jessica Helfand on, 23
 Keetra Dean Dixon on, 137
 Luna Maurer on, 117
 Maira Kalman on, 29
 Michael Bierut on, 41
 Michael Vanderbyl on, 61
 Mieke Gerritzen on, 104–105
 Paula Scher on, 131
 Paul Sahre on, 10–11
 Rick Valicenti on, 47
 Rodrigo Corral on, 81
 Sarah Gephart on, 92
 Stefan Sagmeister on, 75
 Steven Heller on, 99
 Vanessa van Dam on, 111
human-oriented approach to, 128, 129,
 130–133, 137
improvising with, 21, 24 (*See also*
 experimenting)
interaction between forms in, 70
as language proposition, 4
limitless nature of, x
literacy, 2
philosophical approach to, 103, 106
process, viii–ix, 12, 65, 142, 150, 159
production side of, 65
reflective approach to, 103, 104–105
research-based, 34, 123, 136, 142, 159
role of intuition in, 151, 152
scientific approach to, 118–119
simplicity in, 62, 76, 120
as social system, 14
solving problems with (*See*
 problem-solving)
spontaneity and, 74–75
training (*See* design training)

voice (*See* design voice)
workshop, 162–169
graphic designers. *See also* specific
 designers
 female *vs.* male, 85, 86–87
 lack of control by, 17
 marginalization of, 10–11
 role of, 61, 99
 schools of thought that shape, 160–161
 as software developers, 104–105
 voice (*See* design voice)

H

Heath, Chip, 165
Heath, Dan, 165
Helfand, Jessica, 20–25, 146, 150, 160
Heller, Steven, 96–101, 161
Henri Bendel, 84
human-oriented design, 128, 129, 130–133,
 137
humor, 4, 26, 27, 92, 94

I

iconography, 140–141, 144, 146, 148
idealism, 120
illustrations, 10, 26, 80, 84, 90, 142
images. *See also* photographs
 before-and-after, 167–168
 merging language with, 2, 3, 6, 65, 146,
 150
improvisation, 21, 24
Inconvenient Truth, An (Gore), 90
information
 presenting too much, 96–97, 102–103,
 140
 visualizing, 91, 94
information-driven design, 161
instinct, 28, 30
intelligent design, 92
international typographic style, 161
intuition, 152
iPad, 61, 87, 111
iPhone, 111

Q-R